C000295540

ABERGAVENNY
THROUGH TIME
Irena Morgan

AMBERLEY PUBLISHING

Foreword

Abergavenny has changed dramatically over the years, and to see it chronicled in this way is something that I believe is a valuable asset to people interested in the town. As someone who was born and bred here, I can recall some of these changes, although many of them are before my time. The town is full of history, from Roman times onward, and it is presently having to face other changes, which history may show as being milestones in the town's development.

I commend the book to you.

Cllr Samantha Dodd
Mayor of Abergavenny, 2012/13

First published 2012

Amberley Publishing
The Hill, Stroud, Gloucestershire, GL5 4EP
www.amberley-books.com

Copyright © Irena Morgan, 2012

The right of Irena Morgan to be identified as the
Author of this work has been asserted in accordance with
the Copyrights, Designs and Patents Act 1988.

ISBN 978 1 84868 251 1 (print)

All rights reserved. No part of this book may be reprinted
or reproduced or utilised in any form or by any electronic,
mechanical or other means, now known or hereafter
invented, including photocopying and recording, or in
any information storage or retrieval system, without the
permission in writing from the Publishers.

British Library Cataloguing in Publication Data.
A catalogue record for this book is available from the
British Library.

Typesetting by Amberley Publishing.
Printed in Great Britain.

Introduction

Traditionally known as the Gate of Wales, Abergavenny is a lively market town set in the unsurpassed beauty of the Usk Valley on the edge of the Brecon Beacons National Park. The population has grown to around 14,000 and the town is a hub for tourist activities such as walking, cycling, paragliding, canal boating and pony-trekking. Townspeople enjoy annual events such as the carnival, the festival of cycling, the Rotary Club's two-day Steam Rally, the Shire Horse show and two music festivals, Breakin' Out and, on a more poignant note, the Welsh Warrior Festival. This year, the extra bunting came out for a packed Diamond Jubilee programme organised by Abergavenny Town Council, and the Olympic torch relay.

The town has a strong claim to be the culinary capital of Wales, with a number of award-winning restaurants. Each September, one of Britain's premier food festivals is held here, and it has grown steadily since it started in 1999, leading an *Observer Food Monthly* commentator to describe Abergavenny as the 'Glastonbury of food festivals'. More than 30,000 visitors descend over the festival weekend, eager to watch cookery demonstrations by top chefs, listen to – and join in – debates about food production, and sample some of the delicious fare on sale from the 200 specialist stalls staged in landmark venues and in the streets, yards and lanes. A fringe festival is held, while a smaller, one-day Christmas fair has been introduced for December.

Historically, Abergavenny's strategic border location has meant it has been at the centre of warfare during turbulent times. Evidence of this can be found in the museum, set in the ruined Norman castle. On display are archaeological finds dating through the ages back to Norman, Roman and Mesolithic times. The Romans built a fort here named Gobannium (place of the iron smiths) in the middle of the first century. Plaques in one of the town's main car parks at Castle Street mark the spot where they built their defences as part of a network to try and subdue the local Silurian tribes.

Around 1,000 years later, the Normans arrived and Hamelin de Ballon, the first Lord of Abergavenny, built a motte-and-bailey castle topped by a wooden tower around AD 1087. Later the castle was rebuilt in stone, and some of the remains you see today date back to the thirteenth century. Hamelin de Ballon built the Benedictine priory that became St Mary's Priory church. According to one sixteenth-century scribe, Abergavenny Castle 'has been oftner stain'd with the infamy of treachery, than any other castle in Wales'. In these more peaceful times, visitors are more likely to enjoy a picnic and see a play or a concert. The early Norman town grew up alongside the castle, and the first markets were held within the town walls in what is now Nevill Street and St John's Square. Only fragments now remain of these town walls.

Abergavenny endured the ravages of the Black Death during the 1340s, and was devastated by Owain Glyndŵr's raid in 1404 during his fight for an independent Welsh nation. The town eventually recovered, with the development of local industries such as tanning and weaving during the sixteenth and seventeenth centuries, and the growing town became known for its boot and shoemaking, saddlery and glove-making. A particularly fine Abergavenny flannel was made here.

In the mid-eighteenth century, Abergavenny was briefly a 'spa town' when doctors prescribed goats' milk for consumptive patients, leading to an influx of visitors; goat hair was made into exceptionally fine white periwigs, and a method of wig bleaching was invented here. The end of the eighteenth century was a prosperous time and many of the old Tudor houses were refurbished with fashionable Georgian frontages. Abergavenny holds an important place in Welsh literary and cultural history. From 1833 to 1854, under the patronage of Lady Llanover, the Abergavenny Cymreigyddion Society attracted scholars, poets and scientists from Europe and beyond, and helped to support the ailing woollen industries. The town began to expand once more with the coming of the railways in the 1850s, and benefited from links with the iron and coal industries of the Gwent Valleys. The Monmouthshire & Brecon Canal was built and is now a popular tourist attraction.

In the 1950s and '60s, much of the heart of the old town was destroyed under a slum-clearance scheme. Fortunately, some features such as fireplaces, doors and oak panelling were salvaged and are now on display in the museum. The biggest question facing Abergavenny in recent times has been the future of the livestock market in the centre of town. Monmouthshire County Council plan to replace the mart with a new out-of-town one so that the current site can be sold off for development.

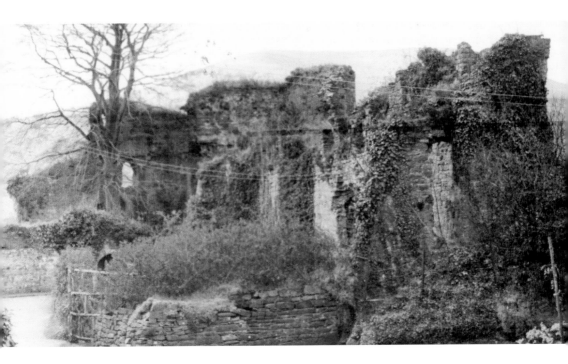

Abergavenny Castle

Abergavenny Castle is set against a spectacular backdrop of mountains, and was once a powerful symbol of Norman authority. The Lords of Abergavenny, the Nevill family, have not lived there since the fifteenth century. The castle was left neglected and overgrown until the late Victorian era, when it was turned into fashionable pleasure grounds. The remains of the Great Hall are seen below in the centre. It was here that the Norman Lord William de Braose massacred Sitsyllt and other Welsh leaders at Christmas 1175, which earned the castle its reputation for infamy. The gatehouse to the side of the hall was strengthened in the early 1400s at the time of attacks by the Welsh leader Owain Glyndŵr. Still visible are the stops for the heavy doors, draw-bar holes and the battered base of the west-facing wall.

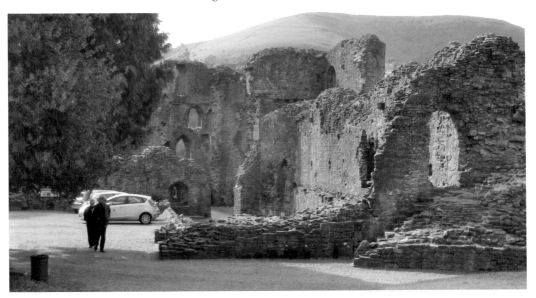

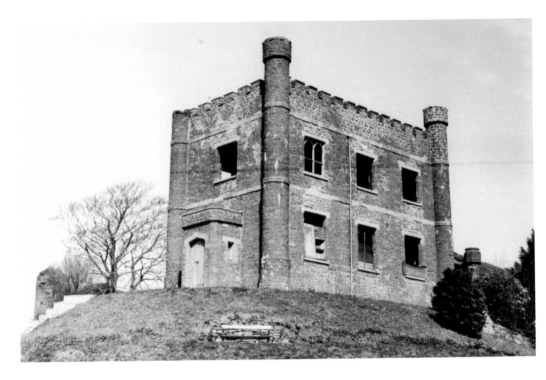

Castle Keep

The 'keep' was built around 1819 on the original motte as a hunting lodge for the then Marquess of Abergavenny when he visited the town. It has been restored and now houses Abergavenny Museum, founded in 1959. The museum's displays tell the story of the town from prehistory through to the present day. It holds regular, changing exhibitions and a number of family activities. On show are a Victorian Welsh farmhouse kitchen, a saddler's workshop, and the complete interior of the Basil Jones grocery shop, moved lock, stock and barrel from Cross Street in the town centre.

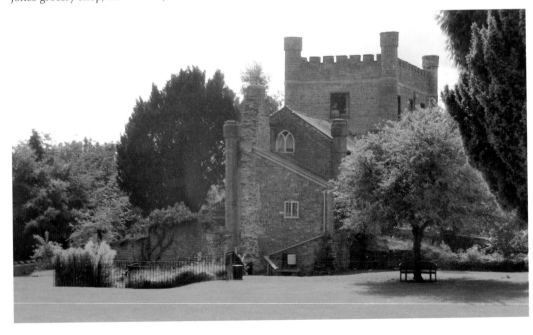

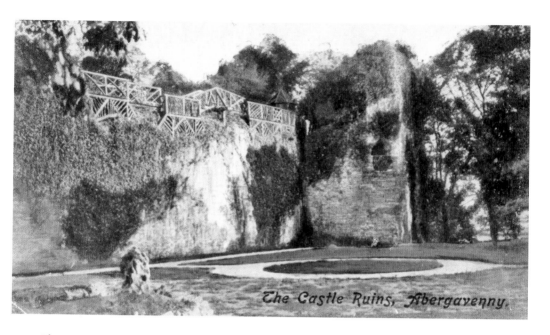

The Castle Ruins, Abergavenny.

The Marquess and Elvis

The castle has been open to the public since 1881 and is leased by the Marquess of Abergavenny to the local authority. A walkway was built along the castle walls, flower beds were planted and at times a bandstand, tennis courts and even tea-rooms were provided. The castle is still used for entertainment. Plays and concerts are held and it is one of the main venues for Abergavenny Food Festival. In 2005, 'Elvis' (aka electrician Keith Davies) arrived by helicopter (below), reminiscent of John Lennon's style of travel when The Beatles appeared at the Town Hall ballroom in 1963. 'Elvis', the 'Sweet Inspirations' and the 'Memphis Mafia' played to a sell-out audience in a fundraising concert for the town's Chamber of Trade.

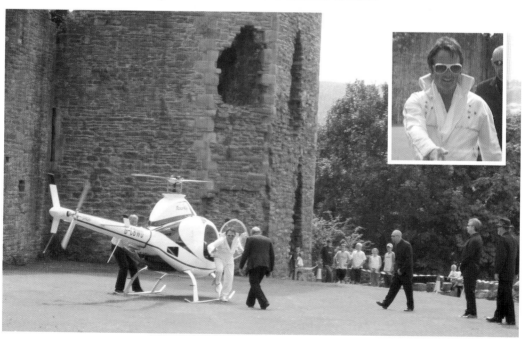

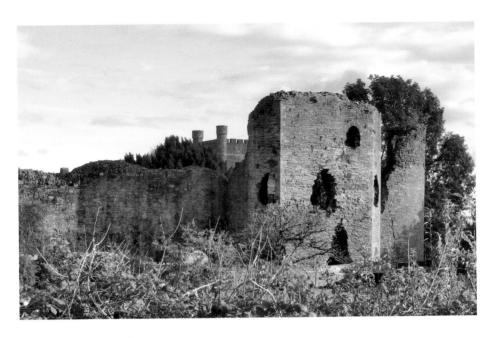

Castle Street Car Park

This view is from Castle Street car park, the site on which the Romans built their fort, Gobannium. The castle was founded around 1087 by the Norman lord Hamelin de Ballon. On the right are the south-west towers, which would have provided accommodation for the lords and their families when they visited. The castle was destroyed in 1233 and then rebuilt, and was slighted during the Civil War.

The spectacular and commanding view from the castle, below, helps to show why both the Romans and Normans chose almost the same spot on the long, low hill high up over the River Usk to build their strongholds. The river's course has changed and would then have been closer to the castle.

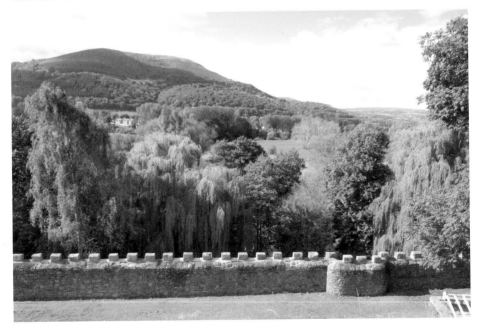

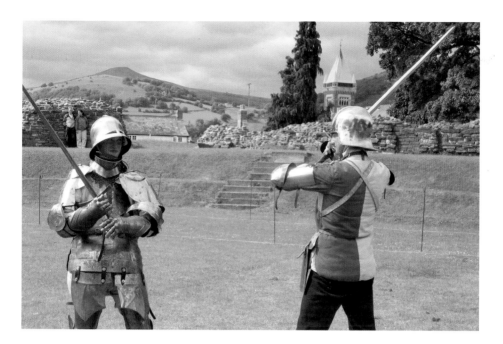

Knights

Knights clash at the castle during a re-enactment. The castle was at its most splendid in the thirteenth and fourteenth centuries. It was still strong enough to be held for the King in the Civil War, but Charles I ordered it to be rendered uninhabitable in 1645 as Parliamentary forces approached. It was then used as a quarry for local buildings until castles became more appreciated. Each summer, the highly acclaimed Gwent Young People's Theatre stages an outdoor production at the castle when the audience is invited to bring along a rug and a picnic. In 2012, they performed *Midsummer Night's Dream*. The scene below is from 2005 when they staged *Lark Rise*. The group is based at the Melville Theatre in the Drama Centre, Pen-y-Pound.

St Mary's Priory Church

St Mary's Priory church has been described as 'the Westminster Abbey of South Wales'. It contains some superbly restored monuments and sculptures, among the most important collections of any parish church in Britain. The church was founded after 1087 as a Benedictine priory by Hamelin de Ballon, the first Norman Lord of Abergavenny. The church has some finely carved fifteenth-century monastic choir stalls. The oldest monument is the tomb of Eva de Braose, who died in 1246; her effigy bears a shield decorated with the Cantiloupe fleurs-de-lis. Another fine effigy is the wooden figure of Sir John de Hastings, dating from around 1325, who significantly contributed to the rebuilding of the church. The tomb of Dr David Lewis (*d.* 1584) lies in the Lewis chapel. He was a local man who achieved fame by becoming an advisor to Queen Elizabeth I and was appointed first principal of Jesus College, Oxford. The church has a modern and spacious hall, the St Mary's Priory Centre, officially opened in 2000 by HRH the Prince of Wales. Part of the complex contains the restored Tithe Barn. Perhaps the greatest feature of the church is the fifteenth-century 'Jesse tree', below, an extraordinary figure that once formed the base of an elaborate construction depicting the lineage of Jesus Christ from Jesse, the father of King David. Carved from one solid piece of oak, it was originally highly coloured, and is believed to be the only surviving one made of wood left in the world.

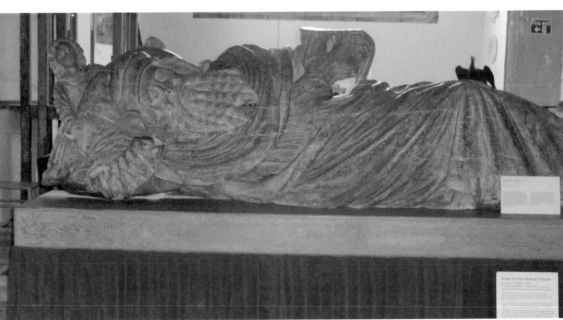

Herbert Chapel

The Herbert chapel before it was restored. Among the tombs are those of William ap Thomas and Gwladys. Sir William fought at Agincourt with Henry V (where Gwladys' father, Sir David Gam, and her first husband, Sir Robert Vaughan, died). William, a member of the Herbert dynasty, was later knighted and built the Yellow Tower at Raglan Castle. William was known as the Blue Knight of Gwent because of the colour of his armour, and Gwladys was known as 'the Star of Abergavenny' for her beauty. Below, pictured from the other side of the restored chapel is the seventeenth-century tomb of William and Joan Baker on the far right, showing the couple kneeling at prayer. It is elaborately and beautifully carved in local stone.

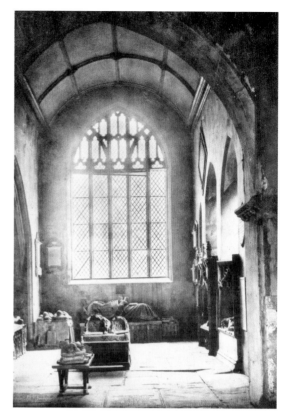

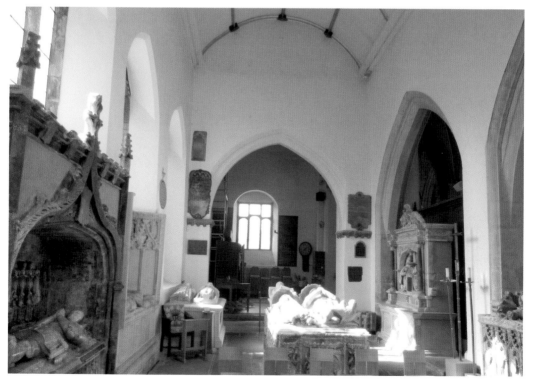

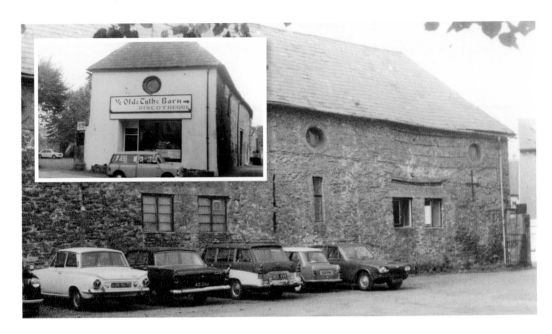

The Tithe Barn

The Tithe Barn was originally built in the twelfth century to store tithes, the taxes paid to the priory. After the Dissolution of the Monasteries in the sixteenth century, the building was sold off and used for a variety of purposes, including a theatre, carpet shop and, around 1970, a discotheque (inset). The Tithe Barn was bought back by the church, funding was secured, and conservation work started in 2002. It is now a heritage and education centre (below) with an interactive exhibition chronicling the history of St Mary's Priory and the town, and it houses the Abergavenny Tapestry.

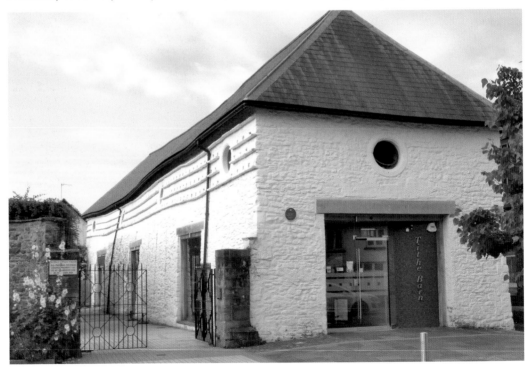

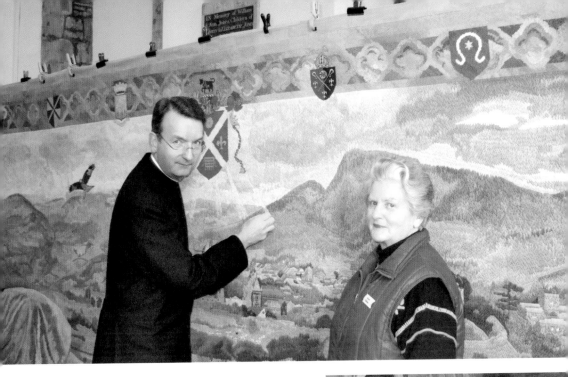

Abergavenny Tapestry

The magnificent Abergavenny Tapestry measures
24 feet by 6 feet and started as a Millennium project.
It is now a major tourist attraction and celebrates
1,000 years of the town's history. The tapestry took a
dedicated team of sixty nearly six years to complete,
and more than 400 shades of wool were used.
Stitchers viewed their work as 'painting with wool'.
Around 5,000 visitors came to see it being made and
were encouraged to join in and sew some stitches.
Most of the work took place in the Lewis chapel at
St Mary's Priory church, where it was mainly on
display. The tapestry took more than 20,000 hours of
dedicated, loving and painstaking work. It then had
to be sent away to be professionally backed. Pictured
is the Very Revd Canon Jeremy Winston with
Mrs Sheila Bevan, chairman of the Tapestry
Committee. Father Jeremy died aged fifty-seven
in November 2011, two months after he left
Abergavenny to be installed as Dean of Monmouth.
As part of the Lewis chapel restoration, Father
Jeremy had wanted to see a stained glass window
designed to show the 'missing tree' part of the Jesse
tree. A memorial fund has been set up to create
that window as a tribute to 'a man of vision and
inspiration'. Two wall hangings inside the church
(right) were designed and made by Elizabeth Brown.
The hangings, 20 feet long and 40 inches wide, took
ten months to complete.

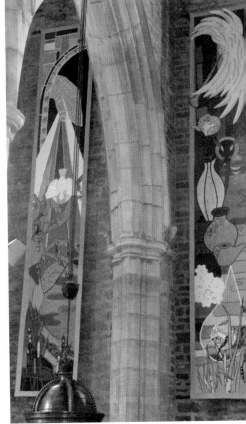

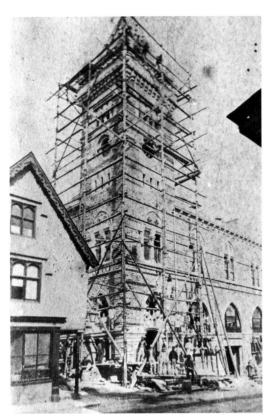

Town Hall I

Abergavenny Town Hall and marketplace was built in 1870/71 in the early French Gothic style. It replaced an earlier marketplace designed by the noted architect John Nash before he was famous. The money to build the Nash market came from Philip Jones of Llanarth, MP and a member of the Grocers' Company, who left 200 marks in his will to the town because he felt the old market hall was badly situated. The pre-Nash hall stood on a site just in front of the present Town Hall and may be one reason why the road is wider at this point. Improvements to the Nash design were carried out in 1824 by a Mr Westcott. When it became too costly to repair, the Improvement Commissioners, forerunners of the council, decided to replace it. The Victorian Town Hall was constructed of Devonian Old Red Sandstone with Bath limestone ashlar dressings, and has a distinctive green-topped clock tower. At the side are a market hall and a 'butter market'. The tower clock was donated by Crawshay Bailey, the ironmaster who lived at Llanfoist, and was not fitted until around 1876. The clock has a black dial on its north side which may commemorate his death in 1872. Left is another very early photograph of the Town Hall, dated 1875, standing proudly at the top of Cross Street near High Cross. The clock had yet to be installed in the tower. The name High Cross is thought to have originated because it was at a junction, as opposed to the Low Cross junction near the Angel Hotel.

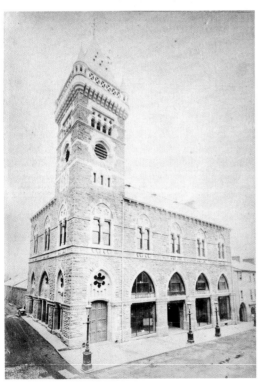

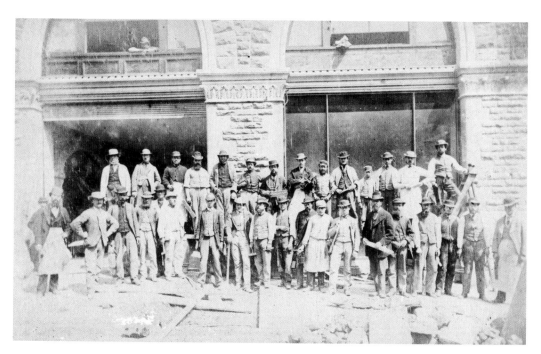

Town Hall II

The architects Wilson & Wilcox of Bath won the tender to design the Town Hall, and S. J. Morelands & Sons of Gloucester were contracted to do the work. Here the workmen look as if they are near to completing their task. There was one recorded fatality while the Town Hall was being built. In 1870, Thomas Watkins, a twenty-six-year-old local labourer, tragically fell to his death working on the tower. Abergavenny Town Hall (right), with its tower and its distinctive green top, can be seen for miles around. It contains offices, a council chamber, the old corn exchange, and its 'hidden gem', the Borough Theatre, where touring companies, performers, local amateur theatre, operatic companies and the Borough Band perform.

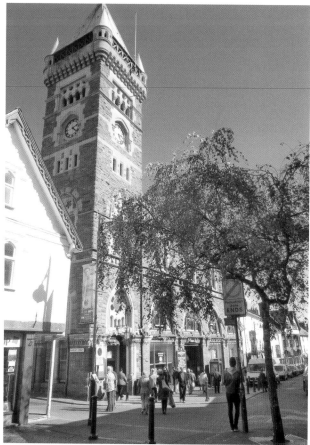

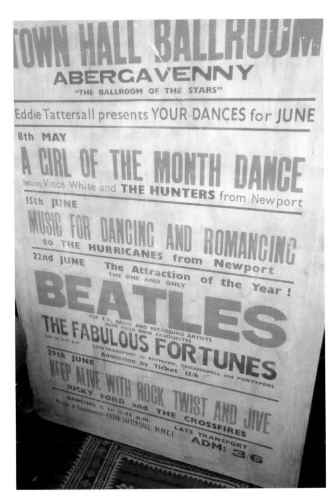

The Beatles

The Beatles came to Abergavenny in June 1963. They had already started to make headline news and commanded big fees but agreed to honour the booking and were paid just £250. Posters advertising the concert have always proved popular as memorabilia and have even formed the basis for fabric patterns. One chair covered with the material was recently found on sale in Australia. John Lennon had to be flown into Abergavenny by helicopter because he had an earlier date at a television studio. They were one of a number of top bands brought to the town by local promoter Eddie Tattersall. The Abergavenny Amateur Operatic and Dramatic Society, known as AAODS, was established in 1911, and is one of the many thriving groups who use the much-loved Borough Theatre (below), which was remodelled in the 1990s.

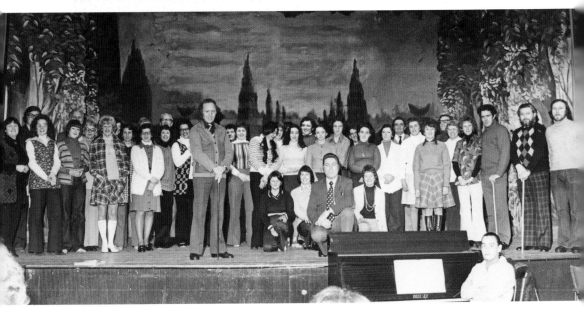

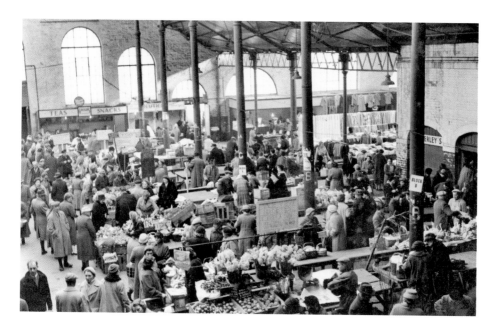

The Market

The market as it looked about fifty years ago. The main general market is held on Tuesdays and stretches into the revamped Brewery Yard car park at the back. Smaller general markets are held on a Friday and Saturday. Other specialist ones are held on a regular basis and include craft fairs, antique or flea markets, and on the fourth Thursday of the month, a farmers' market. Each September the hall and yard become one of the key venues for Abergavenny Food Festival. Below is a Tuesday market as it looks in the twenty-first century. Each year, new market hall decorations are unveiled at the start of each food festival and they are eagerly anticipated. Made by the Arts Alive team, the 2012 theme was 'Leaping Hares and Gorgeous Game Birds'.

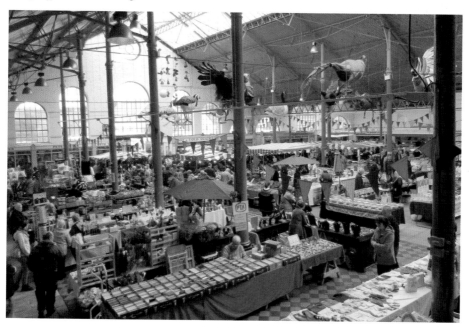

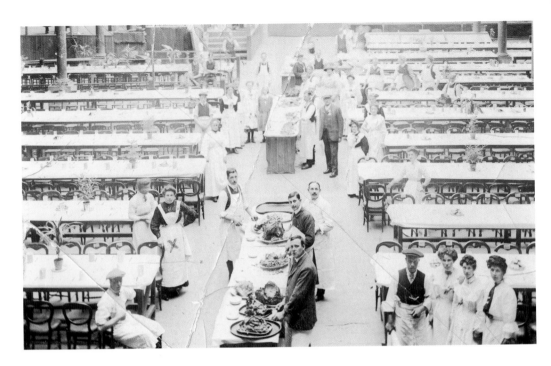

Market Hall I

The Market Hall has often been used for community dining. This photograph dates from the early 1900s and shows the preparations for the arrival of a noted dignitary, probably the Lord Mayor of London or Earl Roberts, the Commander-in-Chief of the British Forces during the Boer War. These days, tables are set out in the Market Hall for the 'Fanfare' community meal in the run up to the food festival with smaller grouping during the festival weekend itself, as pictured below. Each year, volunteers from the Arts Alive group make the hangings which adorn the hall. The design is a closely kept secret until the unveiling at the Fanfare.

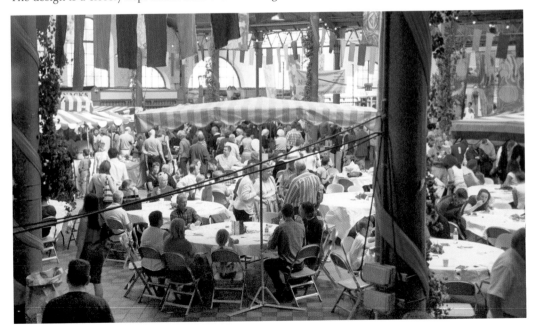

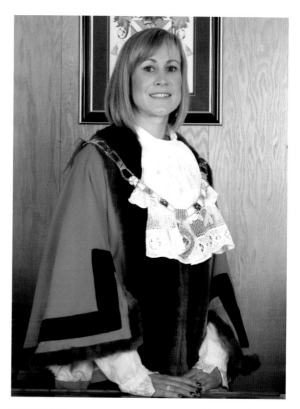

Town Hall III

Councillor Samantha Dodd is the Mayor of Abergavenny for 2012/13 for the town council. Abergavenny also lies within the wider administrative district of Monmouthshire County, whose chairman is County Councillor Maureen Powell, also an Abergavenny town councillor.

Abergavenny Town Hall contains offices for both councils. The top storey was originally built as the Assembly Rooms and was remodelled in 1906; the balcony was added and it was first used as a theatre. The Assembly Rooms became known as the Town Hall Ballroom. The Beatles appeared there, and the ballroom was refitted as a theatre in the 1990s.

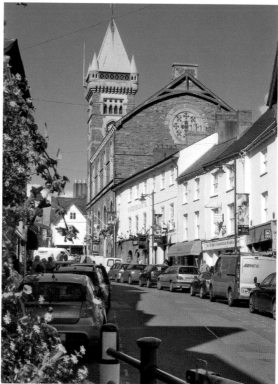

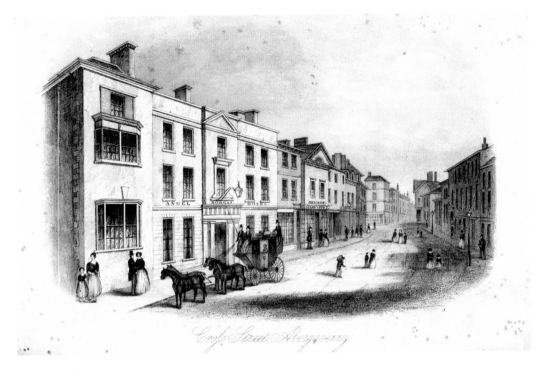

Market Hall II

The Victorian Town Hall had not yet been built so the Market Hall could be the one designed by John Nash. It had a classical front, a covered corn market and an open courtyard surrounded with stalls. The town wall was raised at that point to a height of 14 feet to screen the market from the northerly wind. This bustling scene in 1950s Abergavenny (below) looks as if it could be market day. The shop on the corner with Monk Street says 'Electricity Supply'.

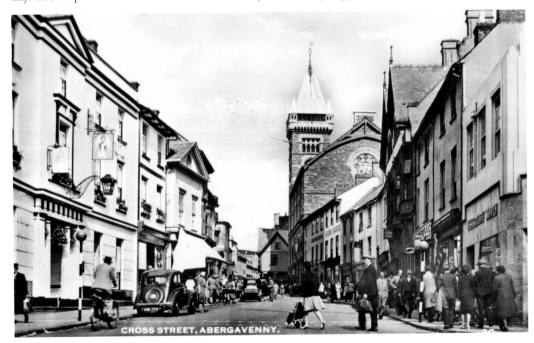

CROSS STREET, ABERGAVENNY.

20

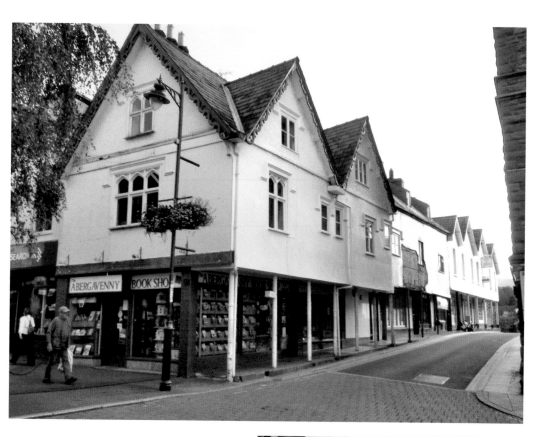

Market Street

The old houses of Market Street with their raised pavement show what much of the town must have looked like in around 1600. The buildings have overhanging first floors, which were originally supported on wooden posts, now replaced by iron ones. The original wooden framework is hidden by plaster. At first, it was just an unnamed alleyway to reach the Cibi brook through a small gate in the town wall. It was described on an 1834 map as Traitor's Lane – legend says that it was where Owain Glyndŵr was let in to devastate the town in 1404. Below we are looking towards the Cross Street end. Market Street has a new gallery and studio, Seventeen Traitor's Lane, which evokes the old name. Scenic Abergavenny has always attracted artists and this is one of the increasing numbers of art shops, galleries and studios to be found throughout the town.

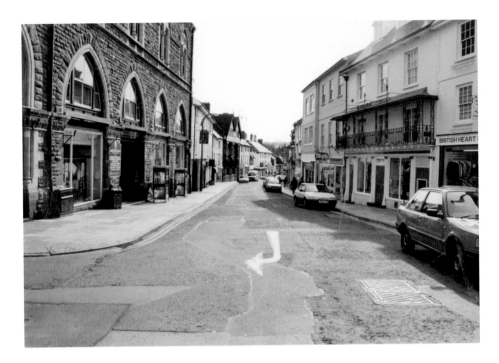

Onion Johnnies

The area between the Town Hall and Boots is where a previous Market Hall is thought to have been sited. The picture was taken in around the 1980s before the front of the Town Hall was refurbished. 'Onion Johnnies' used to be seen regularly throughout the towns of South Wales. It's the nickname given to the Breton farmers who travel over to Wales to sell their produce, one of whom is pictured below during the food festival.

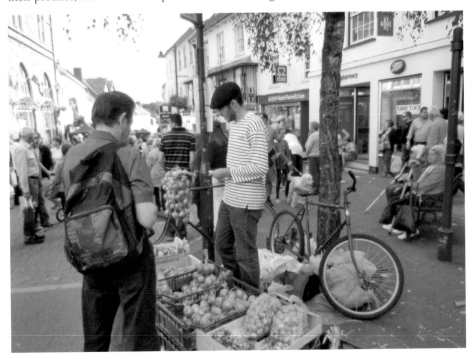

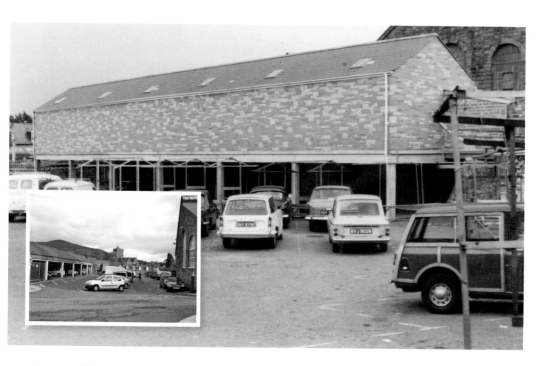

Town Hall Car Park

The lower level of the old car park at the rear of the Town Hall in 1968, which was turned over for market stalls each Tuesday. Inset is the top level. Both levels have been substantially upgraded with terraces, seating areas and a piazza (below). They have extensive granite paving and natural stone walling to form what's now called the Brewery Yard, featuring artworks by artist Howard Bowcott. Apart from bigger market days, both levels are still used as car parks throughout the week.

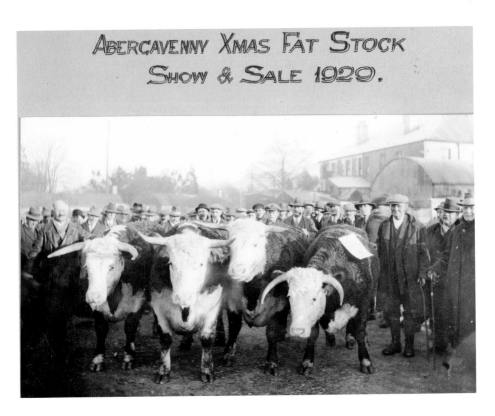

1929 Christmas Fatstock
Winning entries in the 1929 Christmas Fatstock show at Abergavenny Market, with some of the old buildings in the background. Below, farmers crowd round the auction ring at the livestock market.

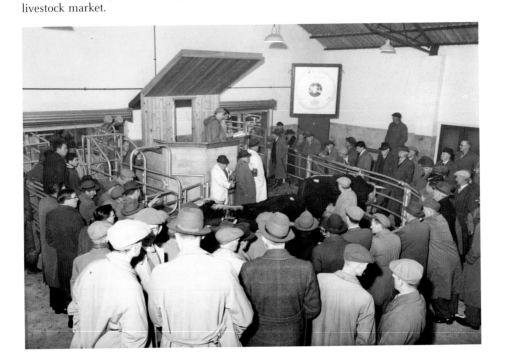

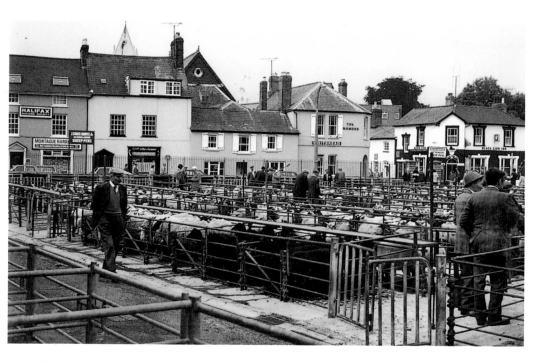

Livestock Market

Abergavenny is unique in Wales in having a livestock market in the centre of town. There has been controversy over Monmouthshire County Council's decision to buy land for an out-of-town market. A group of campaigners has launched a strong campaign to see the market retained. Some of the buildings have been refurbished but hardly anything has changed in the livestock market, pictured below in 2012.

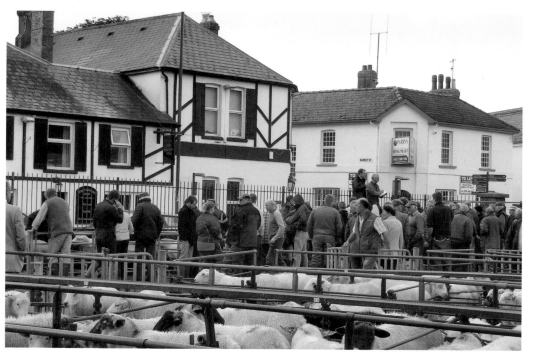

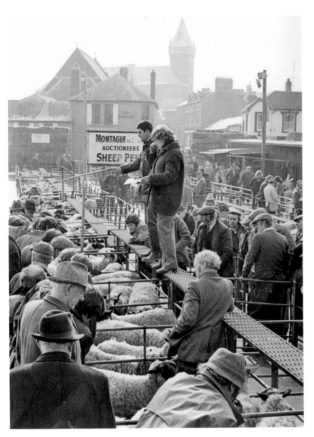

Sheep Market

A packed market in the shadow of the Town Hall tower during the 1970s. Inset, a judge makes a difficult decision: 'Which to choose?' Norman lords first introduced markets to Abergavenny, and the first market place was sited at what is now St John's Square and Nevill Street, which used to be called Cow Street and then Rother Street, after a type of horned cattle. Later, certain streets were earmarked for selling different types of livestock, but residents complained about the noise and mess. A sheep market was established in 1823 at a piece of land near Castle Street, and in 1863, a decision was made to buy a former cricket ground and turn into Abergavenny's livestock market. (Auction and inset photograph © Jenny Barnes)

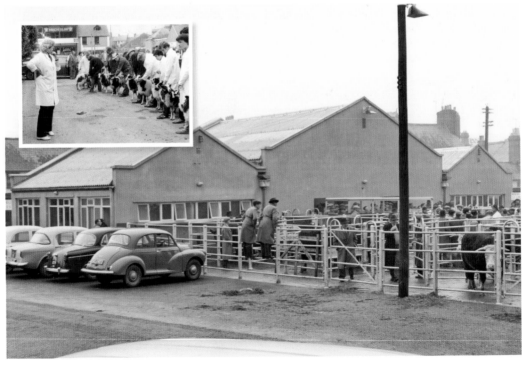

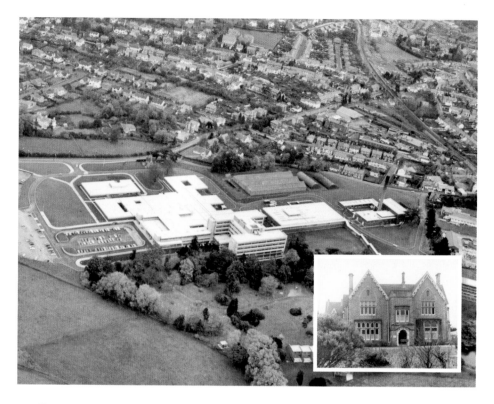

Nevill Hall Hospital

An aerial view of Nevill Hall Hospital after it was opened in 1969. The ambulance station has yet to be built. Nevill Hall Hospital caters for patients in north Gwent, the valleys and South Powys. There is also a new postgraduate medical centre on site. Volunteers run a radio service known as NH Sound for patients as well as the wider community. As seen below, the purpose-built hospital replaced the older Victorian converted mansion (inset), which still remains at the rear of the modern complex. (Inset picture © William Tribe)

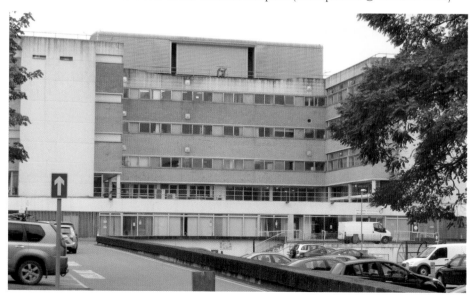

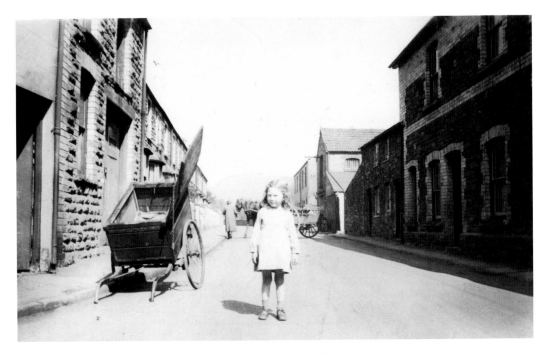

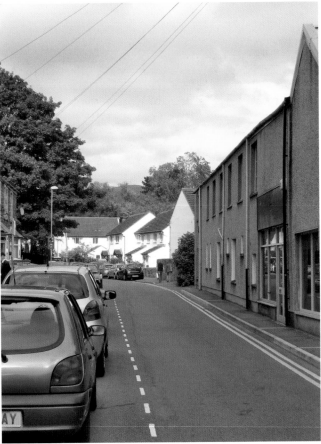

Ross Road

Ross Road was known as Ireland Street because of the numbers of Irish families who once lived there.

This photograph with the unnamed little girl looks to be taken in the 1930s or '40s. Notice the handcart and the lack of cars.

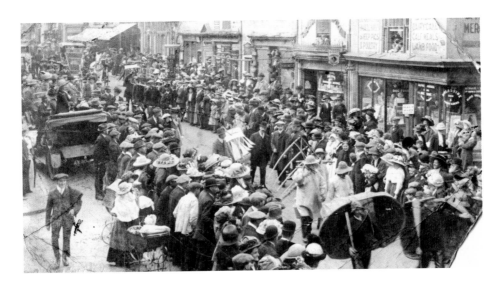

Eisteddfod

Pictured is the procession following the 1913 proclamation of the 1913 National Eisteddfod at Abergavenny, which gives a flavour of British rural life, with the country smocks and coracles and could have given Danny Boyle some ideas for the opening ceremony of the 2012 London Olympics! The Gorsedd stones in Swan Meadows are a permanent reminder of the 1913 Eisteddfod. The circle was moved here from its original site in Monmouth Road. Near the circle are twin standing stones to recognise Abergavenny's own Eisteddfod tradition, and the work of Lord and Lady Llanover in promoting it (below). Abergavenny has a Welsh society, Cymreigyddion y Fenni, and the local Abergavenny Eisteddfod was restarted in 2004.

A companion piece to the standing stones hangs in London in the Clock Tower museum at the House of Commons. Sir Benjamin Hall, Lord Llanover, was the first Commissioner of Works and Public Buildings, and was in charge of the rebuilding of the Houses of Parliament. He stood 6 feet 4 inches tall and it's said that the bell was named in his honour. In 2009, Llanover schoolchildren designed a plaque depicting his life, and went to London to present it to the Keeper of the Clock Tower on the 150th anniversary of the first peal of 'Big Ben'. With them were the Herbert family, descendants of Lord and Lady Llanover.

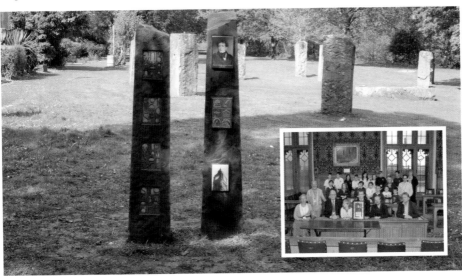

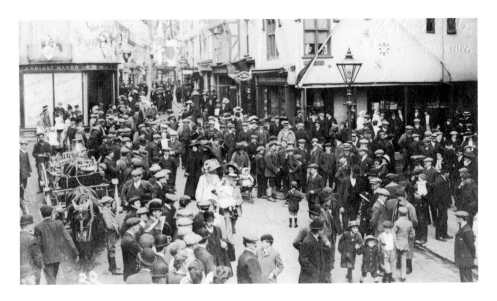

Coronation of George V

The flags and the bunting were flying in June 1911, when Abergavenny residents turned out at High Cross and outside the Town Hall for the Coronation of George V and Queen Mary. In May 1935, residents celebrated the Coronation anniversary with a Royal Jubilee Ball at The Angel Hotel (below). On the committee were B. R. Griffiths, J. D. L. Wagstaffe, A. L. Graham, J. Denbury, Miss K. Cadle, J. H. Wilcox, Mrs Reg Powell, F. G. Atkins, Miss O. Ashcroft, F. W. Blanch, J. Story, the Mayoress Miss H. Beveridge, Dr P. Lornie, the Mayor Councillor M. L. Beveridge and R. C. Thomas. Mr Wagstaffe, middle back row, caused a scandal when he left the country after being accused of embezzlement. It's said he joined the Foreign Legion, and that he was awarded the Croix de Guerre. The warrant for his arrest was withdrawn after his death in the 1950s.

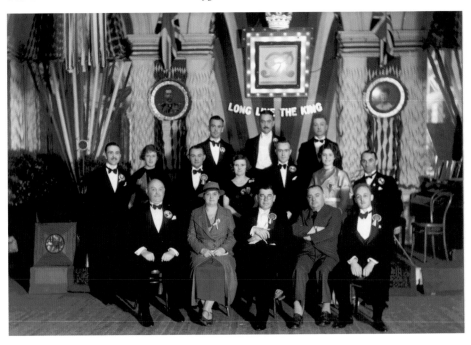

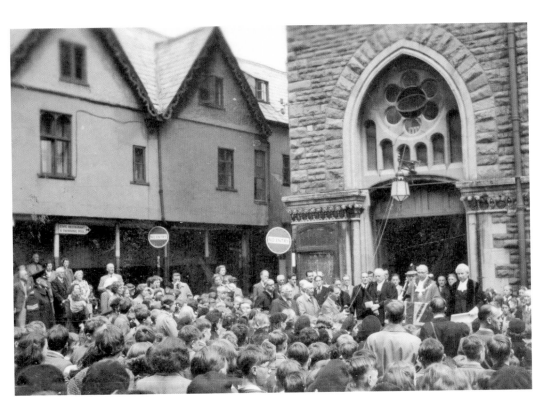

Queen's Coronation I

Townspeople gathered in front of the Town Hall again when the proclamation of the Queen's Coronation was read out in 1953. Below, Councillor Maureen Powell, Chair of Monmouthshire (in blue), and Councillor Samantha Dodd, the Mayor, lead the Diamond Jubilee parade. (Photograph by Andy Sherwill, *Abergavenny Chronicle*)

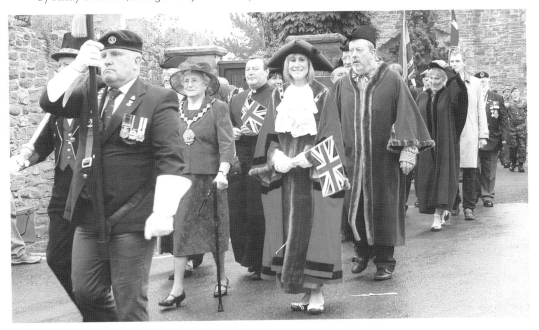

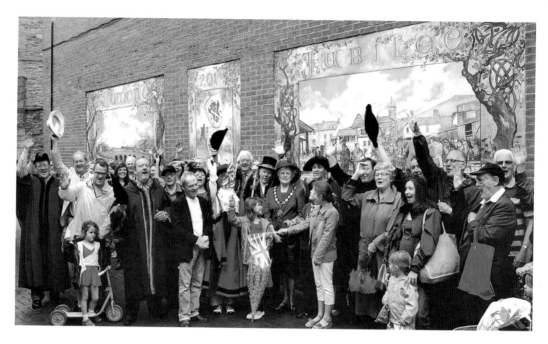

Queen's Diamond Jubilee I

As part of the Queen's Diamond Jubilee, Abergavenny Town Council unveiled a memorial in St John's Street. Local artist Dave Parkinson was commissioned to paint three separate paintings that captured the history of the town. There is a painting of the cattle market, the former railway bridge in Llanfoist, and a painting of three shields of the town's coat of arms, the Welsh flag and the Diamond Jubilee emblem. (Photograph above by Andy Sherwill for the *Abergavenny Chronicle*)

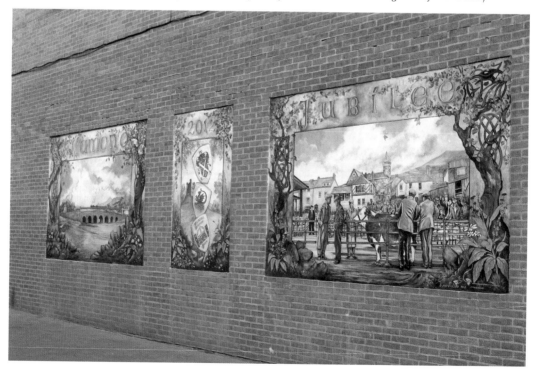

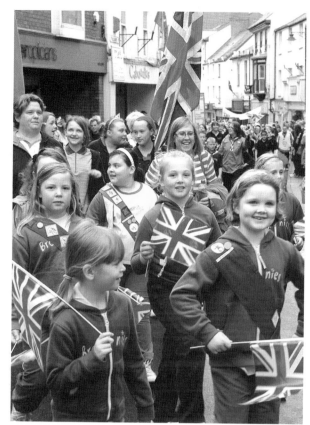

Queen's Diamond Jubilee II
Brownies join in the Diamond Jubilee parade, while residents in the Pegasus Court retirement flats planted a tree for the Diamond Jubilee. (Photographs by Andy Sherwill for the *Abergavenny Chronicle*)

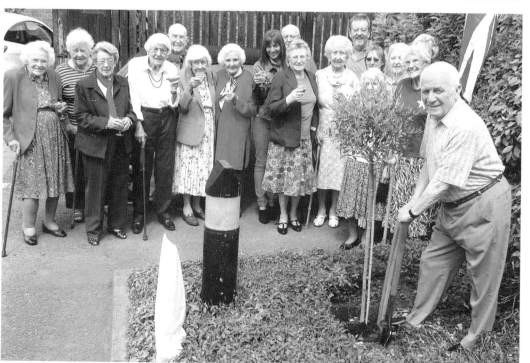

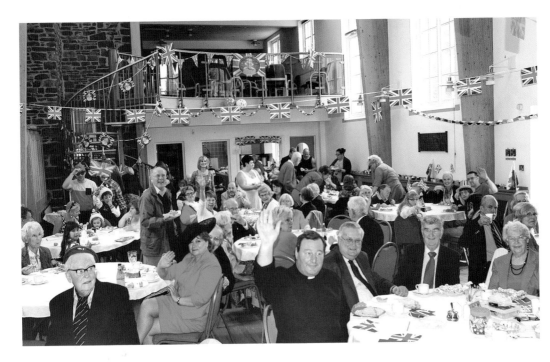

Queen's Diamond Jubilee III

Parishioners from St Mary's Priory church celebrate the Jubilee at the Priory Centre. Pictured in the centre is the Vicar of Abergavenny, the Revd Mark Soady. Below, cadets join in the 2012 Diamond Jubilee parade. They are just about to turn into Lion Street from Frogmore Street. (Photographs by Andy Sherwill for the *Abergavenny Chronicle*)

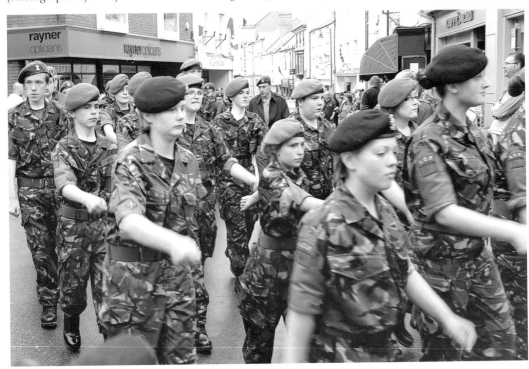

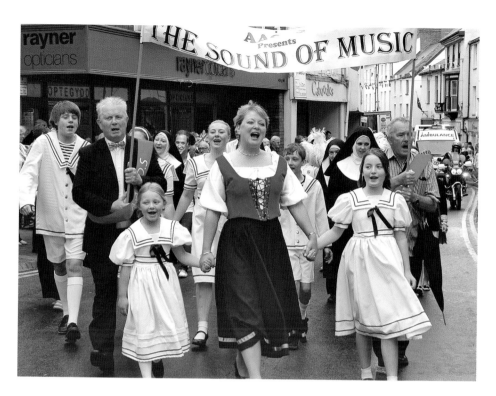

The Sound of Music

Abergavenny Amateur & Operatic Society won first prize in the Jubilee parade with their entry *The Sound of Music*, which they staged for their 2012 production at the Borough Theatre. It was vintage fashion all the way for the four ladies below in the Jubilee parade! (Photographs by Andy Sherwill for the *Abergavenny Chronicle*)

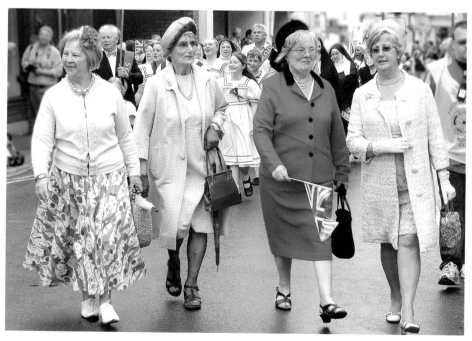

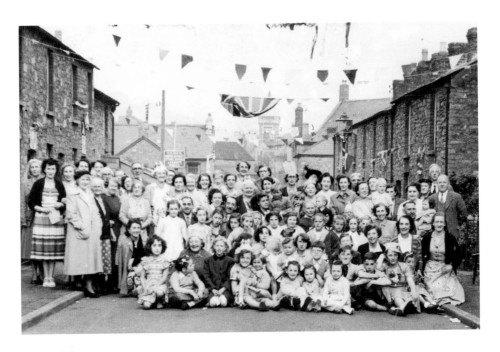

Queen's Coronation II

Residents from Princes Street celebrated the Queen's Coronation in 1952. In the background is the Town Hall tower. In 2012, it was party time for residents in Priory Road who got the bunting out for the Diamond Jubilee (below). (Photograph above from the Albert Lyons collection at Abergavenny Museum. Photograph below by Lesley Flynn for the *Abergavenny Chronicle*)

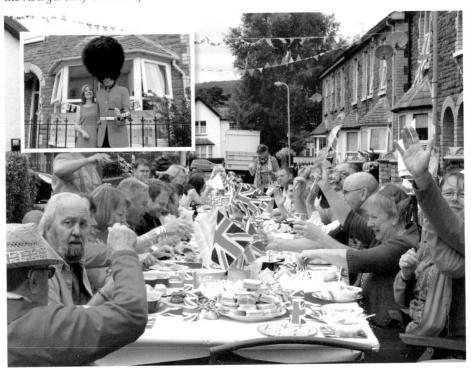

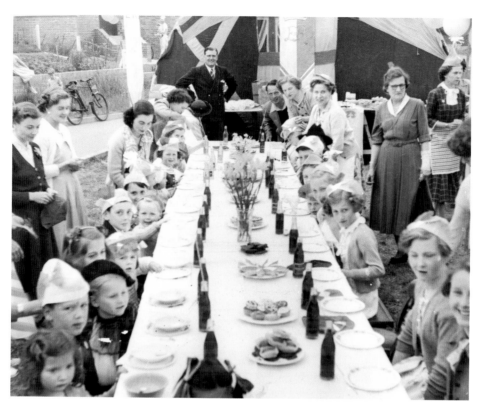

Bishop's Crescent
Residents of Bishop's Crescent, above, and Blorenge Road, below, celebrate the Coronation in 1953. (Photographs from the Albert Lyons collection at Abergavenny Museum)

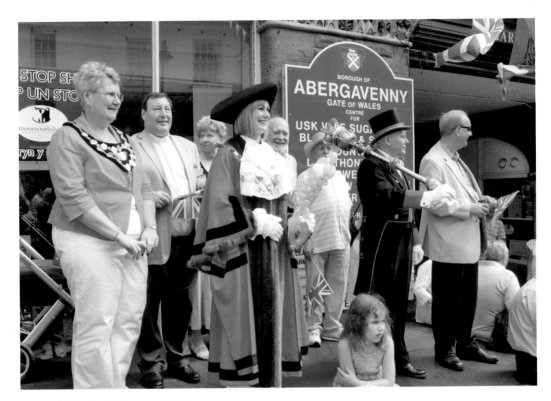

The Olympic Torch

The Mayor of Abergavenny, Councillor Samantha Dodd, her mother, Margaret Dodd, and their guests welcome the Olympic torch to Abergavenny. George Ryley was the torch-bearer in High Street (left). In Abergavenny, the vehicle convoy was forced to take a detour because of the huge crowds in the narrow town centre roads while the torch-bearer ran the planned route. (Photograph above by Philip Sims for Abergavenny Town Council)

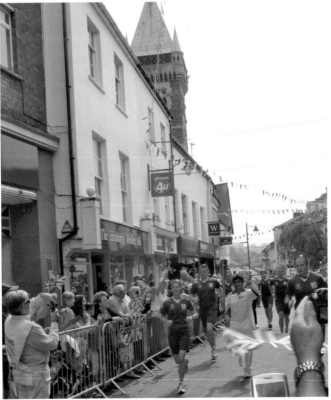

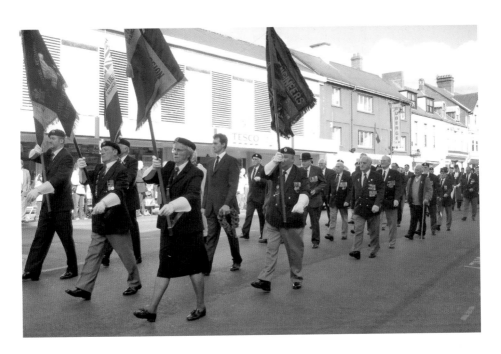

VE Day I

In 2005, Abergavenny celebrated the sixtieth anniversary of VE Day in style. A parade was held with representatives of the services and veterans. In the middle is the MP for Monmouth, David Davies, carrying a wreath to lay at the war memorial. Armoured vehicles took over Cross Street (below) as part of the VE Day sixtieth anniversary celebrations in Abergavenny.

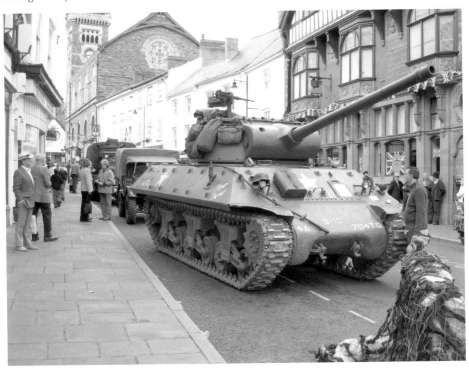

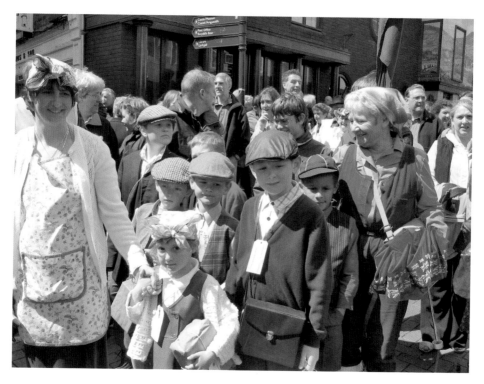

Evacuees

Schoolchildren dressed up as evacuees for the day, carrying their precious bundles wrapped up with string and brown paper; each child was identified by a label. Below, Land Army girls, a nurse and a serviceman celebrate the sixtieth anniversary of VE Day.

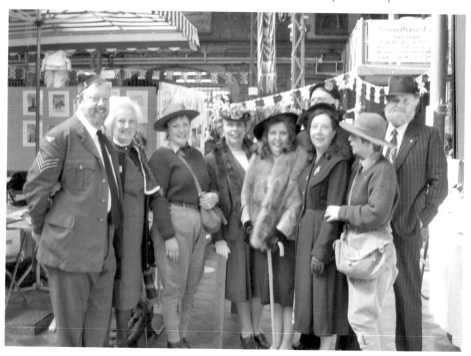

VE Day II
Councillor Chris Woodhouse, the Mayor of Abergavenny in 2005, welcomes the 'evacuees' to the Market Hall while the adults celebrate the VE anniversary celebrations with an evening party. Inset is Councillor John Prosser who helped to organise the celebrations.

Spam, Spam and More Spam

It was Spam, Spam and more Spam washed down with bottles of lemonade for these 'evacuees' at the sixtieth anniversary of VE Day at a tea party held in front of the Town Hall, and even the wet weather didn't spoil their fun. The ladies below look as if they're prepared for everything on the Home Front.

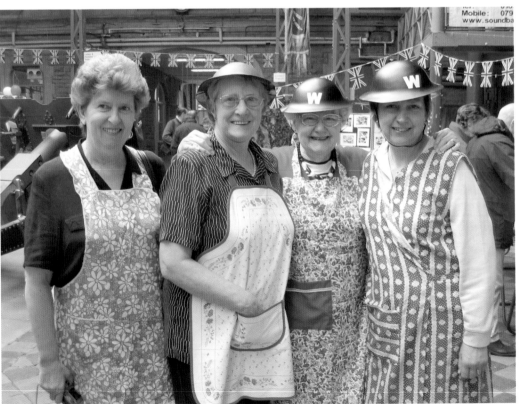

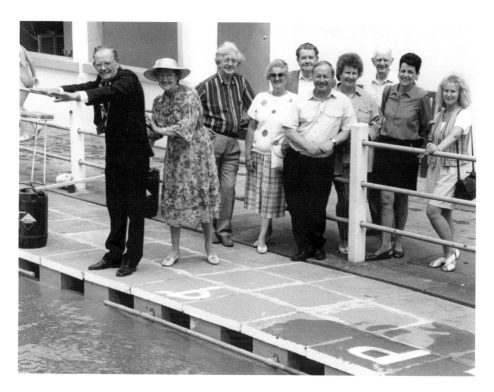

Bailey Park

Over the years, Bailey Park has been a welcome attraction for residents. Many Abergavenny residents recall with fondness their days at the Bailey Park swimming pool which opened in 1939 and recall the sad day when it was closed down in 1996. About to be pushed in at the deep end at the opening of the plunge pool in the 1980s are the Mayor and Mayoress, Ken and Marian Webb, Councillor Douglas, Edna Edwards, Councillor Richard, Margaret Dodd, chairman of the Friends' group Teresa Richards, Councillor Vic Barrett, Town Clerk Trevor Morgan and Verna Bendan. Below, guests watch a life-saving demonstration at the Bailey Park swimming pool.

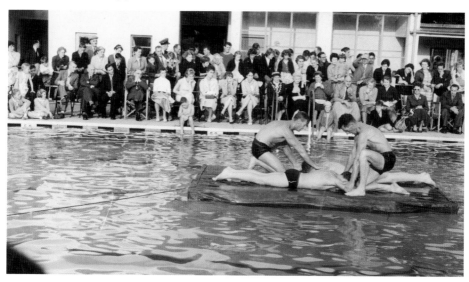

Welsh Warrior Festival and Steam Rally

The Welsh Warrior Festival, held over the August Bank Holiday weekend, raises money for The Richard Hunt Foundation, a charity set up in memory of Private Hunt, twenty-one, which helps ex-servicemen and women. Private Hunt was fatally injured while serving in Afghanistan and died in August 2009. Pictured on stage are members of the Beaufort Male Voice Choir. The children's tug of war at the Rotary Club's Steam Rally in Bailey Park, below, attracts up to 12,000 visitors. (Douglas McArthur)

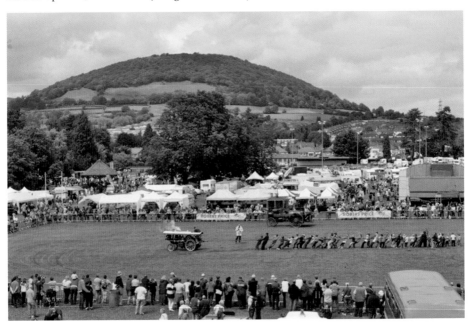

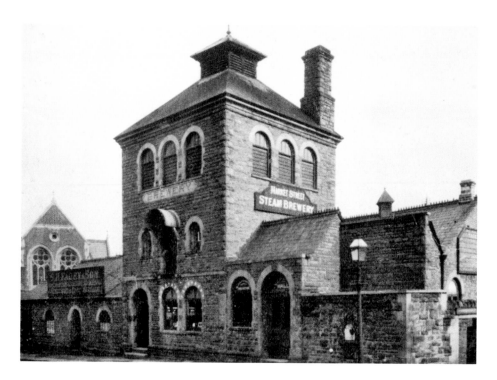

Facey's Brewery

Facey's Brewery stood in Market Street opposite the Greyhound Vaults, now the entrance to the Brewery car park. Facey's was established in the 1830s and moved to Market Street around 1862 near the Cibi brook, which was diverted. Brewing stopped in 1950 and the premises were used as a bottling store and depot. Bethany chapel can be seen on the left. The former Bethany chapel, a Grade II listed building, was built in 1882 and has had a number of uses since it ceased to be used as a place of worship in 1990. It has been a Museum of Childhood and was used by the community recycling project, Homemakers, before they moved to the former workhouse site near Union Road West. It is being restored and turned into an art gallery.

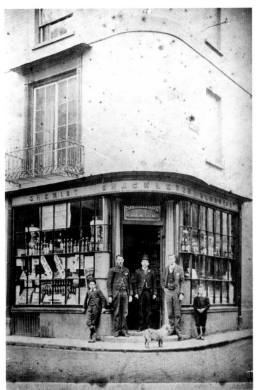

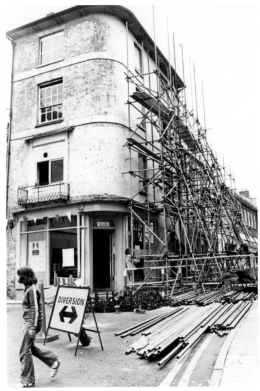

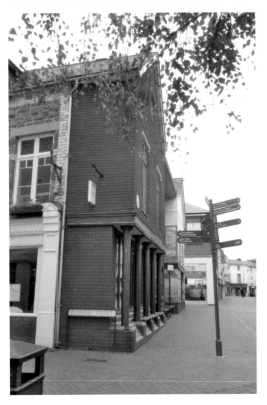

Shackleton's

The Shackleton family opened up a second business in 1898 at 26 High Street on the corner with Flannel Street, but they were there for only a year before moving to Cross Street. Shackleton's is one of the oldest family businesses in Abergavenny, with premises in Nevill Street and Brecon Road. In the 1970s, No. 26 and the other two shops in High Cross were deemed unsafe and scaffolding was erected (above right). Red girders then shored up the side of the building and it acquired the name 'Red Square'. High Street had been closed off and was to remain that way for some years before the unsafe parts of the building were demolished in the 1980s and display cases installed. There is a blue plaque, part of the Abergavenny Local History Society trail, which displays its true name. Left is High Cross, otherwise known as Red Square, as it is in 2012.

Burgesses

The Burgesses ironmongers' signs have been taken down and Boots the chemist has yet to arrive in this photograph taken in the 1970s. One of the previous owners of the ironmongers was Mr Alfred Jackson, who with his brother Ernest helped to found Abergavenny Museum. High Cross marks the start of the pedestrianised town centre.

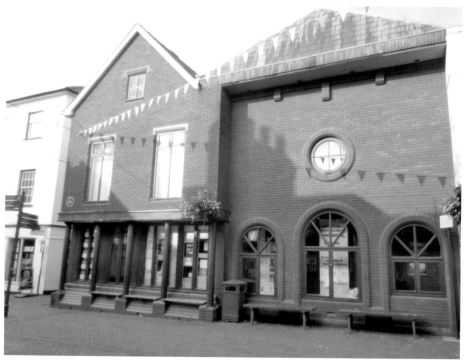

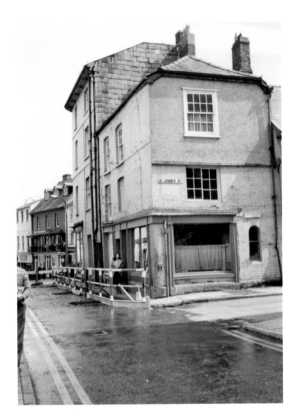

Red Square

'Red Square' from the St John Street side, now the home of the Millennium Mural (below) painted by artist Frances Baines. The mural, funded by Abergavenny Town Council and Monmouthshire County Council, has four windows into the past showing how the town would have looked in the years 1100, 1665, 1856 and 1936. In the background of the mural is a representation of the Skirrid mountain and at the top is the Abergavenny coat of arms.

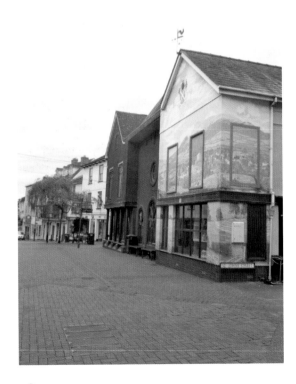

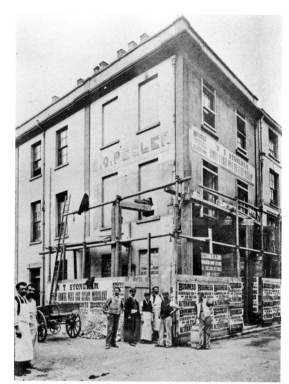

St John Street/High Street

The corner of St John Street and High Street has a long history. Before Bonmarché, previous occupants included Hodges menswear and Stoneham's, a high-class provisions merchant. Before that it was Peglers, a grocer's shop. The tower of St John's, formerly the King Henry VIII Grammar School, and now owned by the Freemasons, is just visible.

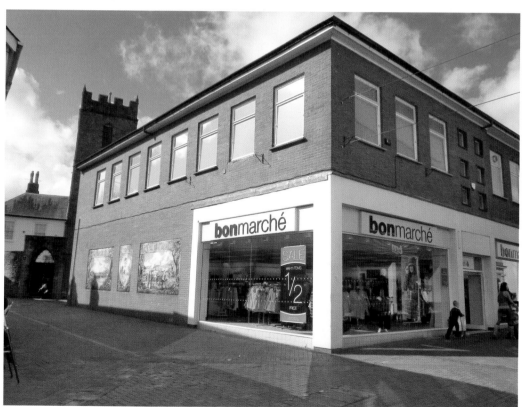

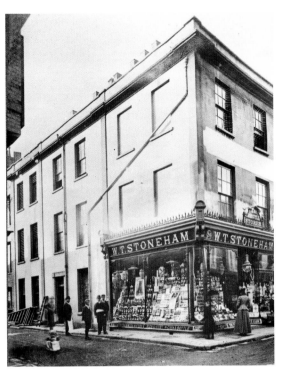

Stoneham's

Stoneham's was a high-class provisions merchant in the Georgian building at 24 High Street, with a narrow, cobbled lane connecting it to Nevill Street. Mr Stoneham came to Abergavenny in 1897, and after he bought the shop he had extensive alterations carried out by J. G. Thomas & Sons. The shop was reopened as the Argyll Stores. There were mahogany counters, old-fashioned tea caddies, spice shelves and a pulley for sending money all the way around the shop.

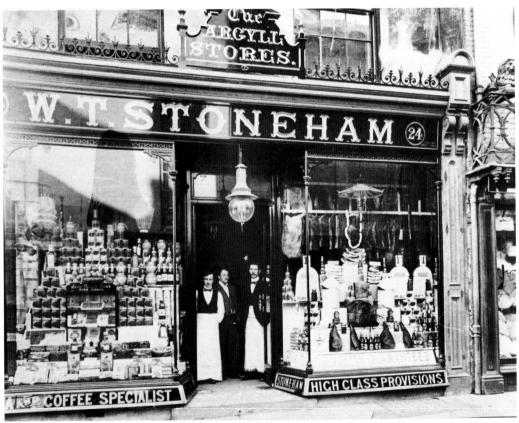

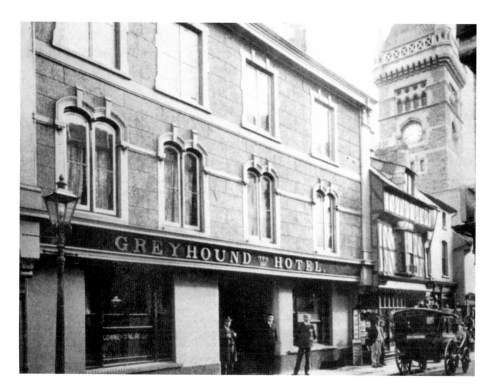

The Greyhound

The Greyhound in High Street was one of Abergavenny's three coaching inns and was once one of the most important hotels in town, with eighteen bedrooms, a ballroom and dining room that could seat 150. The hotel had a bar 24 yards long running parallel with Market Street. The present Greyhound Vaults was originally the tap bar of the hotel. Other businesses now occupy the former Greyhound, including the Holland & Barrett's health food shop, and Waterstones book shop. Remnants of the old stables were said to be in what were once the backyards.

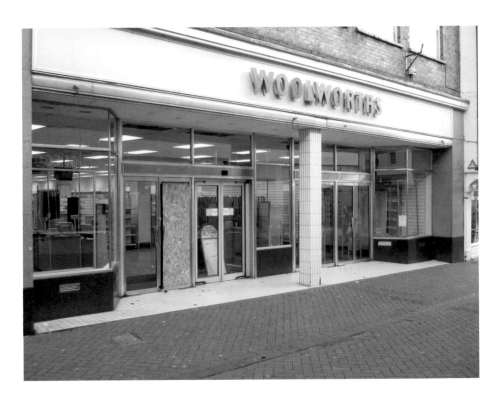

Woolworth's

Over the years the Woolworth's store, opened at High Street in Abergavenny in the early 1920s, sold everything from sweets to CDs, DVDs, books, children's clothing and toys, kitchenware and gardening items. It was a sad day for many when they closed down in December 2008. The premises were taken over by the retailers B&M.

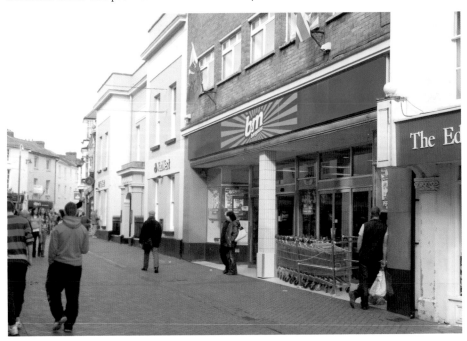

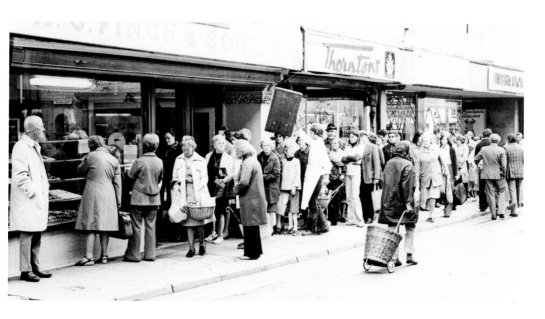

Winter of Discontent

Many bakeries went on strike during the 1977 'winter of discontent' and bread was rationed to customers while the short-lived dispute went on. Here at Pinch & Sons, 6 High Street, the queue stretches down the street, but judging from the window display, it looks as if supplies were running out. Pinch & Sons were in High Street between 1961 and 1984. They moved to Cross Street and opened up a shop at Frogmore Street where St Mary's Bakery is now. The High Street premises were taken over by Jungles, a clothing and fancy goods shop. The Edinburgh Woollen Mill store occupies the premises. (Photograph below © Tony Flynn)

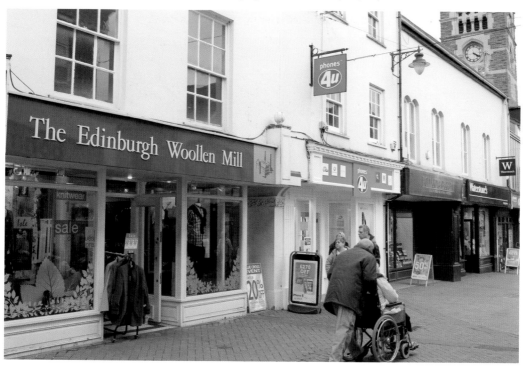

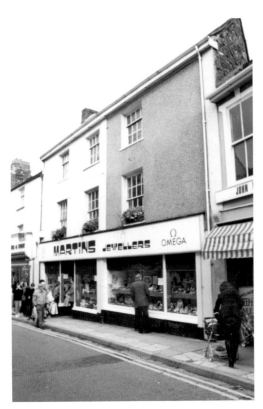

Cibi Walk

On the left is Frogmore Street as it looked before the opening of the Cibi Walk shopping precinct. The precinct and its entrance were constructed after part of the Martin's building was demolished. The precinct was officially opened in 1989. Below is the entrance to Cibi Walk in 2012, and inset is the Shepherd statue at the centre of precinct.

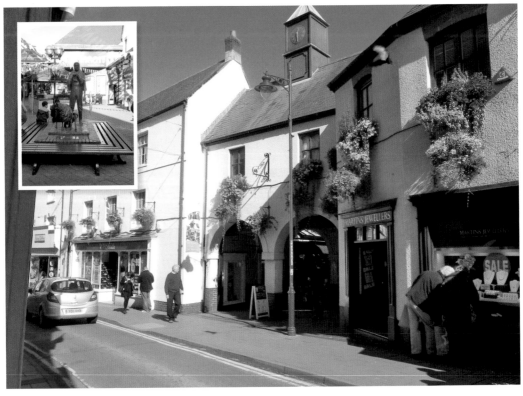

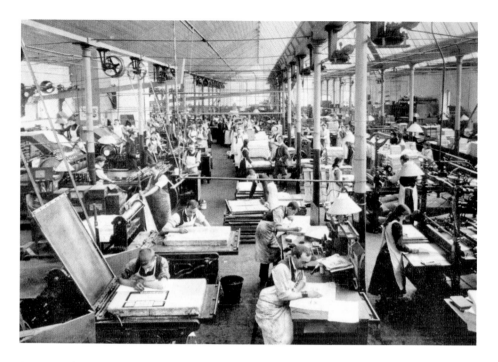

Seargeant's

Seargeant's the printers were at one time the largest printers in Abergavenny. In 1870, a new factory was opened in Queen Street. It was known as the County Works and then the Usk Vale works, and in addition to printing and bookbinding it was a major manufacturer of paper bags. The Usk Vale works was demolished around 1998. The site is at the rear of the Cibi Walk precinct.

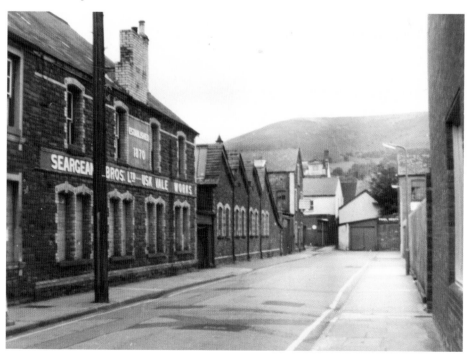

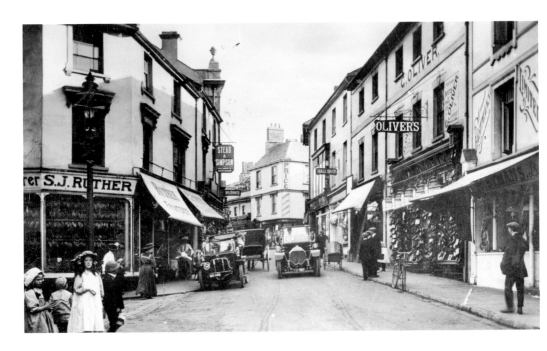

Ruther & Sons

Ruther & Sons, the family grocers, had premises that extended to Lion Street although the main frontage was at Nos 7 and 8 Frogmore Street. In the background is Price's draper's shop. Mr Price's daughter was the actress Madoline Thomas, a veteran of the National Theatre and the Royal Shakespeare Company, who died in 1989, three days before her 100th birthday. Below is a fine display of pheasants and game outside Ruther's Frogmore Street premises. (Photograph below by Eddie Madge for the Burrows 1903 town guide)

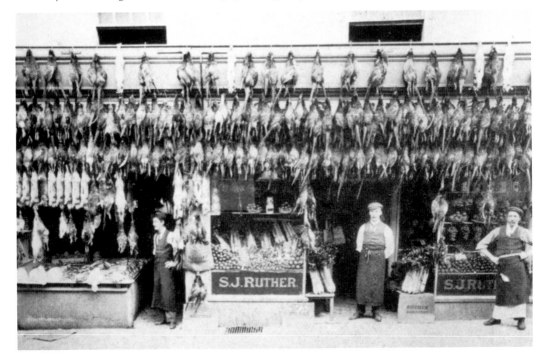

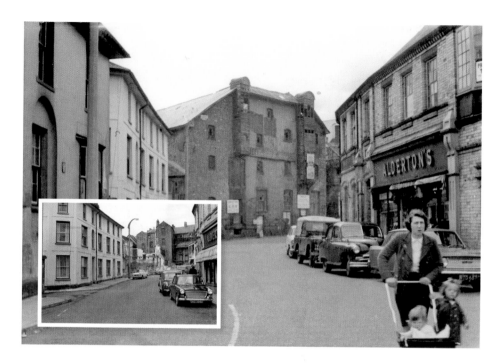

Lion Street/Tiverton Place

Lion Street and Tiverton Place in April 1966. The large building on the corner was initially a brewery and became Tucker's Steam Flour Mills in 1857. A number of houses in Tiverton Place were used to house workmen. In 1907 it was taken over in turn by the Horsington Brothers and used as a builders' store. The inset picture shows the area after the demolition of the brewery. One of the car parks is still known as Horsington's Yard, where other buildings have been demolished (below).

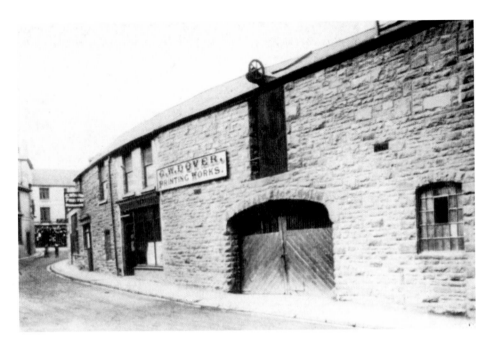

Lion Street I

Many of Abergavenny's streets were named after the animals sold there, such as Chicken Street and Cow/Rother Street (now Nevill Street). But if you're wondering about Lion Street, that was named after the Golden Lion public house in Frogmore Street, later called the Sugar Loaf. Before its closure it was the oldest recorded pub in town. In 1903, Dover's printing works were based in Lion Street, before the firm relocated to Frogmore Street. A number of different businesses occupy the premises in 2012, as seen below.

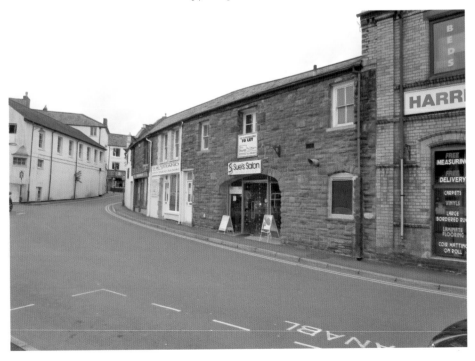

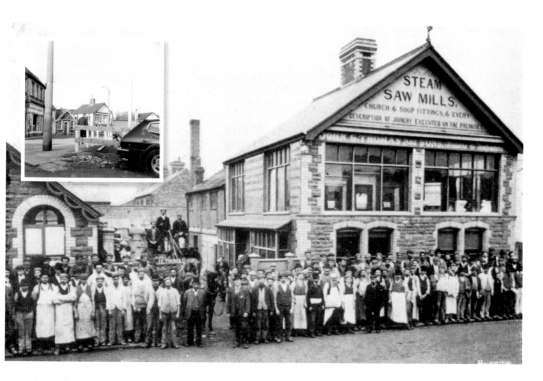

J. G. Thomas

J. G. Thomas the builder was established in 1874, and employed a substantial number of staff, judging from this photograph. The firm carried out church and shop-fittings, high-class decorating, built conservatories and greenhouses. The building was demolished and a car park built.

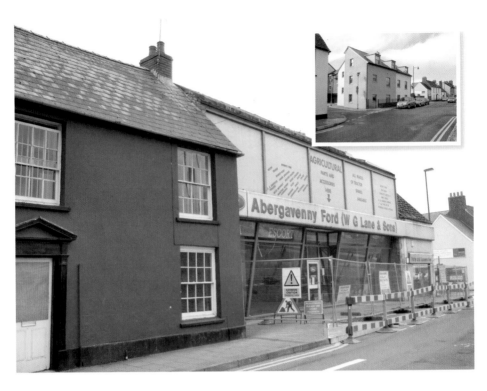

Lion Street II

Lion Street before the W. G. Lane & Sons' Garage was demolished. The inset shows the new housing adjoining the Brewery Yard. Below is Lion Street in the 1960s.

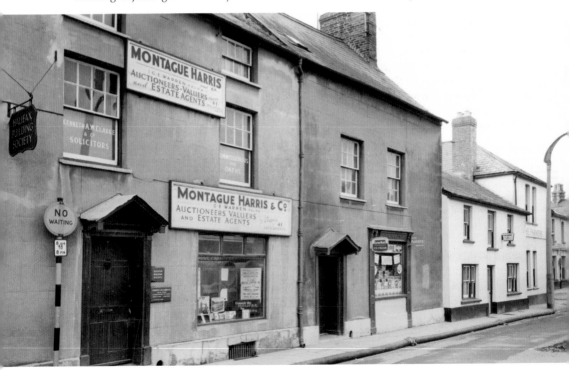

High Street

Burton's menswear moved into
16–18 High Street in 1936. Before
that it was Price's draper's. From
1936, the upstairs section was the
Lucania Billiard Room, which
in 1975 became the Chevron
nightclub. Look at 22 High Street
(now Greggs) to see a replica fire
insurance plaque. The original is
at Abergavenny Museum (right).
These plaques were placed by fire
insurance companies to identify
the buildings they covered. This
one came from the Birmingham
Fire Insurance Company, which
later became Barclays, and which
provided Abergavenny's first
Merryweather manual fire engine,
used in the town until 1921.
Plaques of this sort were used
all over the country and showed
which brigade was responsible for
fighting the fire. These fire marks
represented some of the earliest
examples of the advertiser's art.

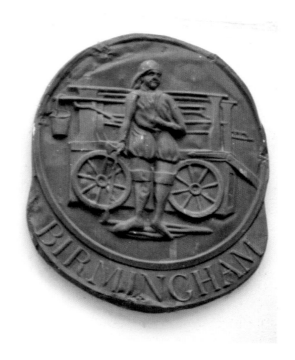

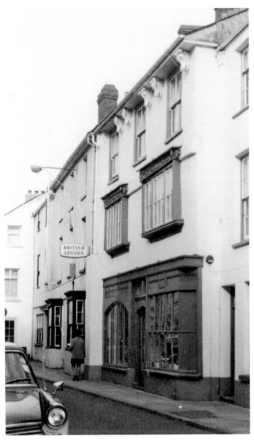

Cow Inn

This building was probably built around 1600 as a town house of the Vaughan family of Tretower. It would have been a half-timbered building with its gable end towards the street and its first storey would have jettied out beyond the first floor. Between 1780 and the 1860s, the house became the Cow Inn, and it's thought that the cow heads under the eaves were added at this time. The chevron with three children's heads is the Vaughan family crest and can be seen again in the Herbert chapel in St Mary's. The single roses may be in remembrance of family members who fought in the Wars of the Roses – on opposing sides perhaps. There are both the red rose of Lancaster and the white rose of York. Note also the Welsh dragon, the little fox, and the letters H. L. – probably the initials of the carver. An altar stone, originally from St John's church, was discovered walled up in a chimney breast of the old Cow Inn, and presented to Holy Trinity church. In 1871 the house was occupied by clothier and general outfitter David Gwynne, and for a time it was occupied by Charles Price.

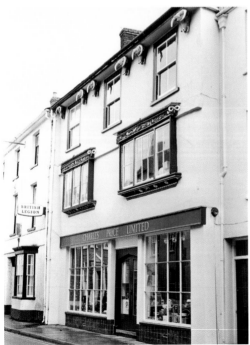

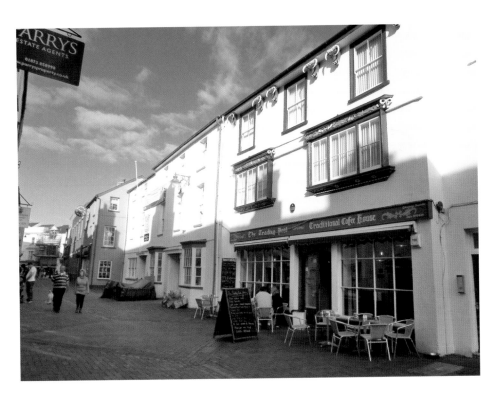

The Trading Post

The Trading Post coffee shop and bistro has been trading at 14 Nevill Street since 2004, and the company also runs the Tithe Barn food hall. On the left is the former British Legion Club, now undergoing redevelopment. Most of the buildings in Nevill Street have substantial sixteenth-century remains inside, with Georgian frontages built as the town prospered. This view is towards St John's Square.

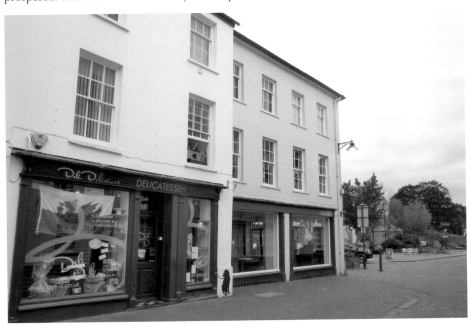

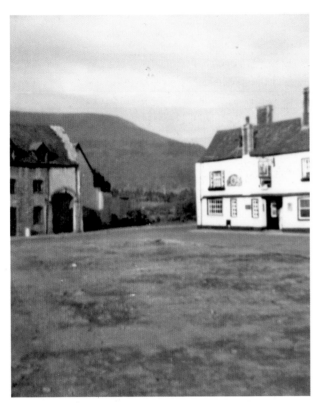

St John's Square I

St John's Square after demolition. Between 1957 and 1968, much of the heart of the old town was destroyed under the old Abergavenny Borough Council's slum clearance scheme. Chicken Street and parts of Tudor Street, Castle Street and Flannel Street were bulldozed. Unfortunately, the buildings, thought to contain nothing of historical or architectural interest, proved to be much older than their façades suggested. Early seventeenth-century wall paintings were found and features such as fireplaces, doors, oak panelling and windows were salvaged and taken to the museum, but a lot was destroyed. Below is the view towards the Town Hall from Castle Street where the post office now stands.

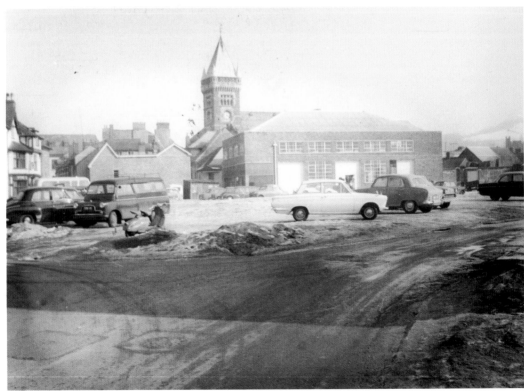

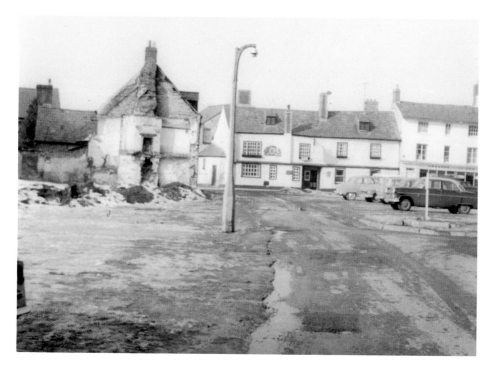

Views from Castle Street

A view of the Kings Arms and Nevill Street from Castle Street. West Gate, or Tudor Gate, was one of the main gates in the town wall at the point where Castle Street and Tudor Street now meet. It was named after Jasper Tudor, the great uncle of Henry VIII, who was at one time Lord of Abergavenny. Below is the view towards St John's church from Castle Street.

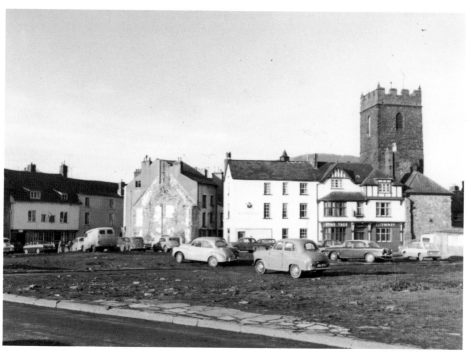

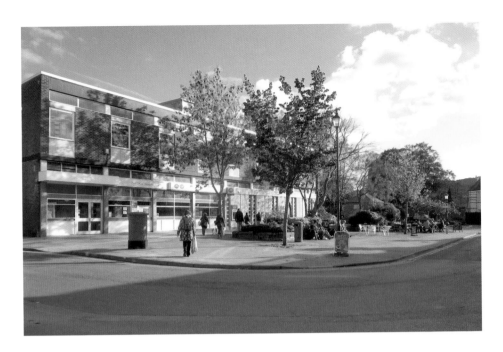

St John's Square II

St John's Square and the post office. A blue plaque and a children's plaque, both put up by Abergavenny Local History Society on the wall of the post office, mark the site of the first markets in Abergavenny. The Kings Arms (below) is a typical sixteenth- or seventeenth-century inn. At the front of the building is a royal coat of arms, thought to have been put up in Victorian times. In the Barn bar there is an inscription written by soldiers billeted there during the Napoleonic Wars: 'Good quartering forever 1817. King & 15th Huzzars Hall Troop 24.'

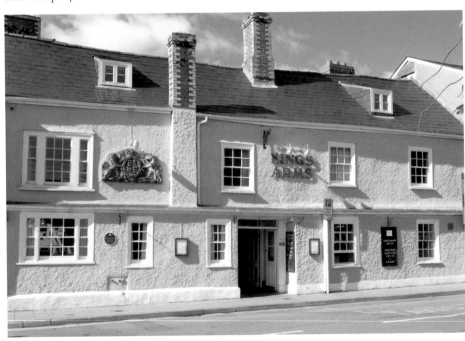

Chicken Street and St John's Street

A view from what was Chicken Street to the Kings Arms. Chicken Street was so called because poultry was sold there, and only the part between Flannel Street and the square remains. St John's church was probably first built in the early 1300s but became disused after St Mary's was used as the parish church. In 1542, Henry VIII founded the grammar school by giving St John's to house the school, supported by tithes previously given to the priory. Town burgesses were given control of the school, but when they refused to swear allegiance to William and Mary in 1689 they lost the royal charter and the right to administer the 'royal school'. In the meantime, the school's headmaster was appointed from Jesus College, Oxford. In 1750 the tower was rebuilt. In 1898 the pupils moved to a new school at Pen-y-Pound and St John's was bought by the Freemasons for their lodge.

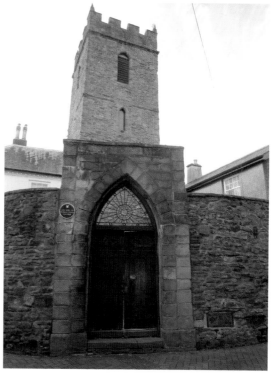

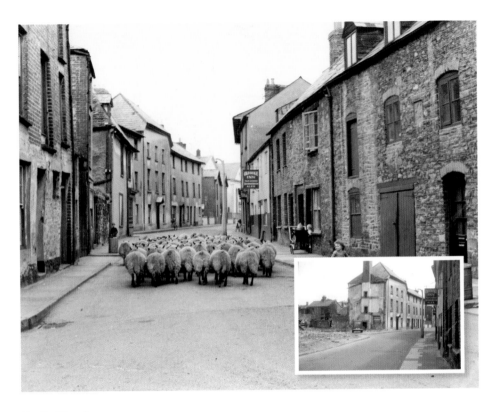

Castle Street

Sheep being driven to market in Castle Street in the 1950s. Before the livestock market was built, there was a sheep market on what is now the Castle Street car park from 1825 to 1863. Below is the view along Castle Street to the Methodist church, dated 1829, and the United Reformed church, originally built in 1792.

Inset: Demolition work has begun in Castle Street.

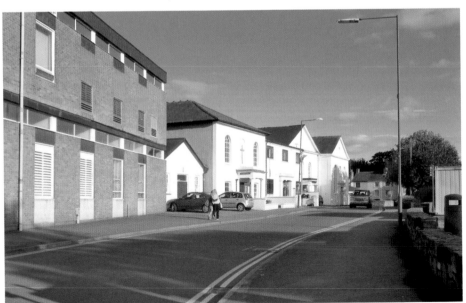

Flannel Street

Only a part of Flannel Street now remains. It used to have a sharp bend where the vehicular access to the post office is and then join up with Castle Street. In the nineteenth century it was known as Butchers' Row, probably because there were so many butchers' shops there. Below is the Hen and Chickens public house in Flannel Street.

Inset: the Flannel Street plaque. Abergavenny Flannel was particularly fine and soft. The remains of a loom were found in the roof of the adjoining building during alterations. Flannel was also brought into the town from the countryside to be sold at market.

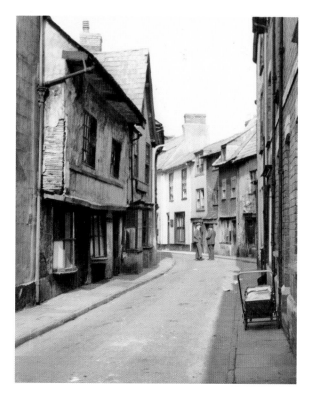

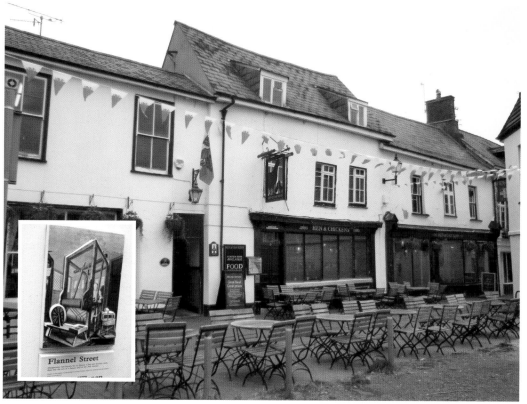

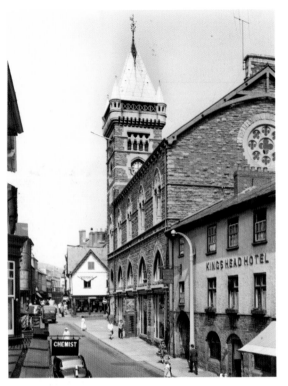

The Kings Head

The Kings Head is one of the most prominently situated hotels, right next to the Town Hall and marketplace. It is thought to be medieval in origin with a fifteenth-century archway wide enough for carts to pass through. The earliest mention goes back to 1689 in the will of a landlord. In 1836 the Abergavenny Improvement Commissioners, forerunners of the local authority, granted permission to the proprietor, William Watkins, to move the medieval arch to its present position. Left is a view of the hotel in the 1960s and below how it looked in 2012.

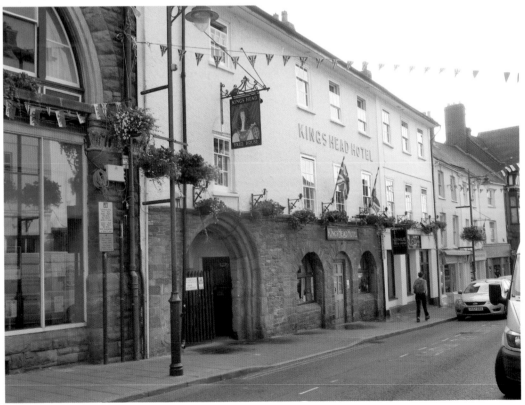

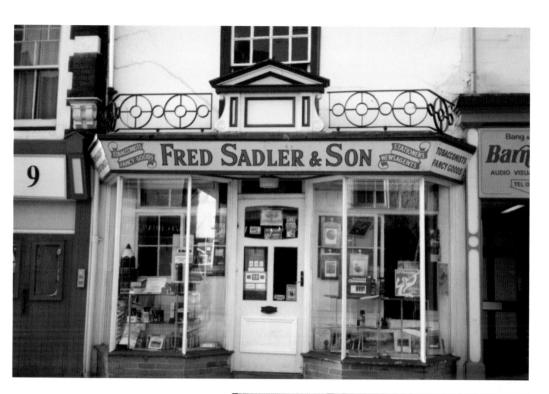

Sadler's

Sadler's, the newsagents at 8 Cross Street, was first owned by the Sadler family in 1908. The approximate age of the building is thought to be from around 1600. It was run by two brothers, Tom and Viv Sadler, and sold everything from newspapers to artist materials. According to the Abergavenny Local History Society Street Survey, some of the original beams in the ceiling were ships' beams. The building was converted into The Art Shop (right) around 2002, keeping all the original wood and flagstone floors, lime-plastered walls, beams and Victorian shop fittings. (Photograph above by Granville Hollister)

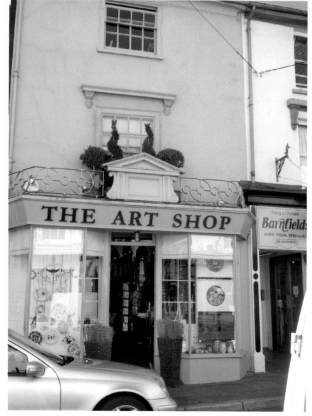

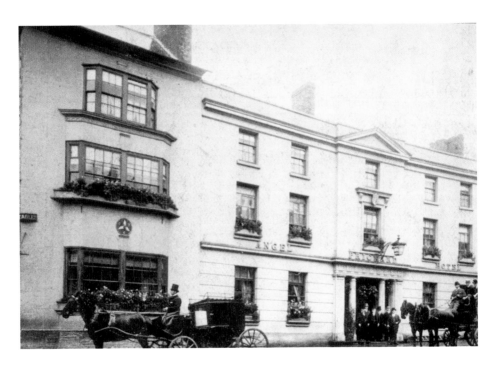

The Angel Hotel

This photograph of the Angel Hotel, with its *c.* 1820 broad frontage, dates from 1903 when it was owned by John Prichard, whose name is emblazoned on the front of the building. The Angel was one of Abergavenny's three coaching inns; the others were the Greyhound and the George Inn in Frogmore Street. The earliest record of the hotel was when it was sold to William Dinwoodie in December 1721. The Angel Hotel has been extensively refurbished and is now one of the premier hotels in the area (below). In 2011, the Angel won a Tea Guild national award for the best afternoon tea.

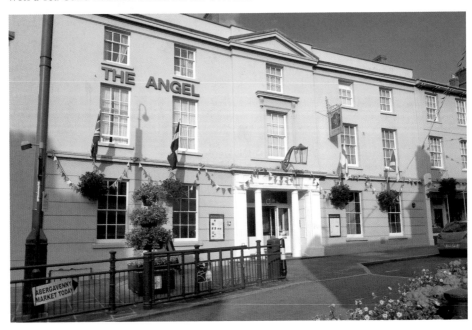

The Sun Inn

The Sun Inn on a market day in the 1920s. Cymreigyddion y Fenni, the Abergavenny Welsh Society, was founded here on 2 November 1833. Now renamed the Coach and Horses Inn (below), the front of the building has a blue plaque marking the site of the medieval south gate in the town wall.

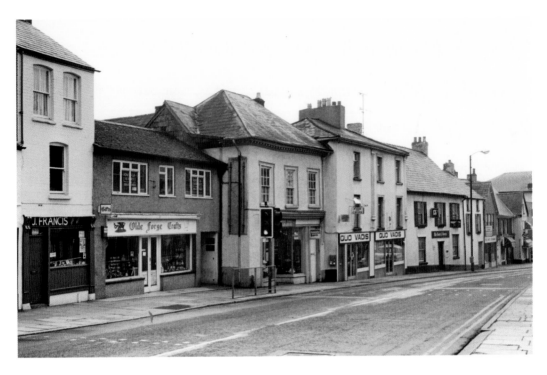

J. Francis

This view of Cross Street shows the stretch from the J. Francis cobblers' shop at 46a to Gunter House around the 1970s. The Francis family first moved into the shop in 1929. Pictured below in 2012, the cobblers' shop is now an artist's studio and shop, renamed Jacobi – 'Not the Cobblers', while the Old Forge Craft Shop has gone.

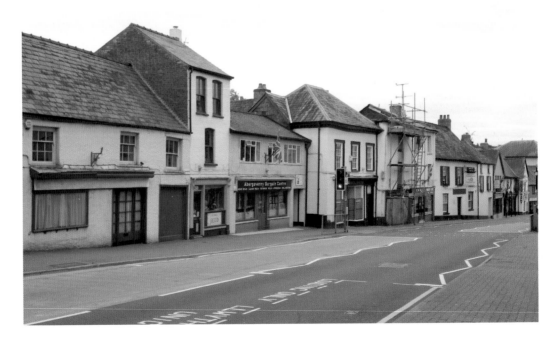

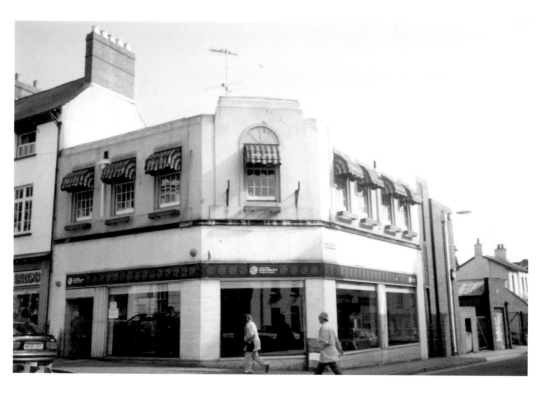

Cross Street/Monk Street

The building at the corner of Cross Street and Monk Street was acquired by the electricity board and rebuilt in 1932. It's thought that the junction was the 'Low Cross' as opposed to the High Cross junction near the Town Hall. In 2012, the Art Deco-style frontage has been smartened up and it is now an optician's. Two doors further on stands Lloyds bank, described by John Newman as a 'Jacobean fantasy' of 1895–97, designed by A. E. Lloyd-Oswell.

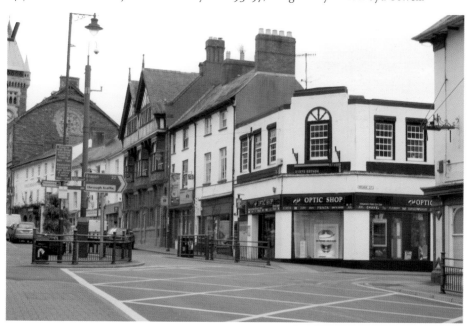

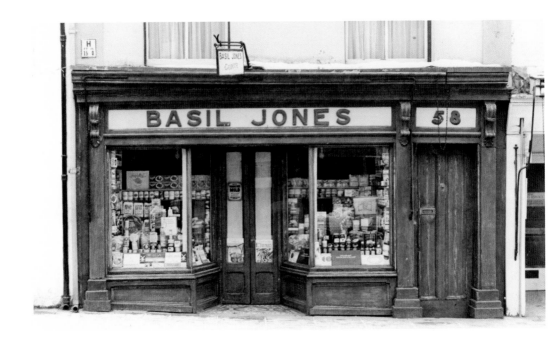

Basil Jones

The Basil Jones grocery shop has long gone from Cross Street – but the contents were acquired in 1994 by Abergavenny Museum. Some of the packaging dated back to the 1930s. Conservators had to carefully remove some of the original stock, such as biscuits, and the shop was recreated within the museum as a delightful display. Often visitors can remember the original shop, and the museum has a 'memory book' where they can record their thoughts. In 2012, the shop is the Cwtch café (below) – *Cwtch* means cuddle in Welsh.

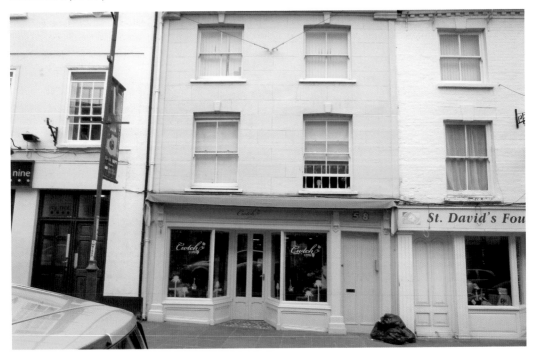

Gunter House

Gunter House in Cross Street once stood just outside the medieval town gate. Here lived Thomas Gunter, a Catholic and Justice of the Peace. The ground floor is much altered but there is still a richly decorated ceiling on the first floor. After Henry VIII's break with Rome, Catholicism was discouraged and at times actively persecuted. Yet Thomas Gunter openly boasted of large attendances at the celebration of mass in his house. In 1678 Titus Oats stirred up anti-Catholic action which spread throughout the country. In Abergavenny, the magistrates were pressed into arresting two priests, David Lewis, a son of the headmaster of the Abergavenny Grammar School, and Phillip Evans, both of whom said Mass in the Gunter House chapel. Both priests were tried and executed. Both were canonised and there is a memorial to St David Lewis in Our Lady and St Michael's Roman Catholic church in Pen-y-Pound. A History Society plaque marks the house in Cross Street. The mural, known as the Adoration of the Magi (below), which adorned the altar of the Gunter House chapel, is now on display in the castle museum. The chapel and mural were discovered during alterations in 1907, in the attic room in the right-hand gable.

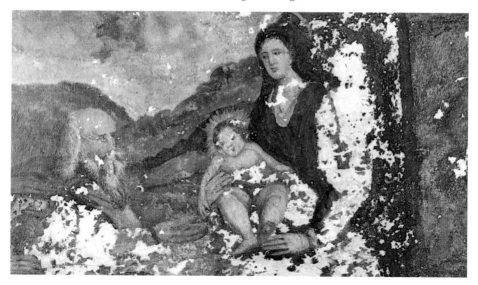

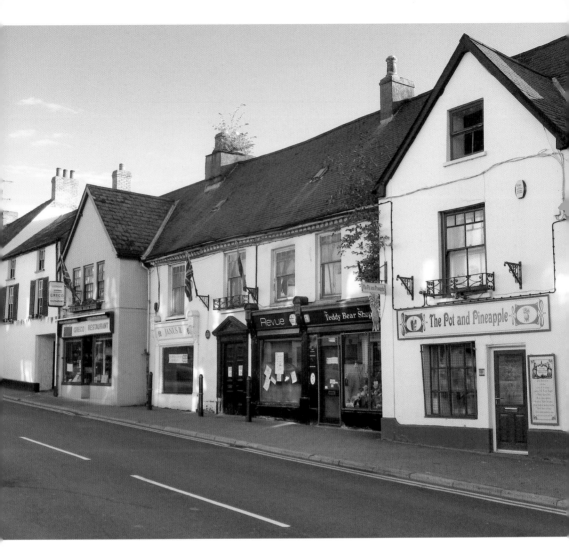

The Pot and Pineapple

In 2012, a traditional sweet shop, the Pot and Pineapple, opened up at Gunter House, which maintains a strong Gunter connection with the choice of name. The historic building was originally constructed in the early years of the seventeenth century and it was home to generations of the Gunter Family. Walter Gunter, who was born around 1717, was the last of the family to reside there. Two Gunter cousins, both named James, went to London to work in the confectionery business set up by their aunt, Mrs Negri. In 1777, Walter's son James became a partner in the business named the Pot and Pine Apple at fashionable 7–8 Berkeley Square and created a sweet empire that would continue to be run by his family for several generations.

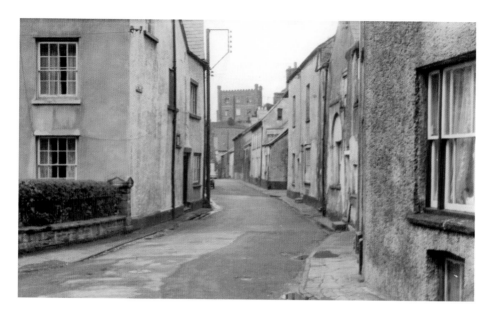

Mill Street

Looking towards the castle from Mill Street, which was mostly demolished in the 'slum clearances' of the late 1950s and early '60s. A tanning industry has existed in Abergavenny since at least 1691. The eighteenth-century Tan House was once the master tanner's home, and is now part of the Pegasus Court retirement complex. Tan pits and workshops lay nearby. The leather industry was then one of the most important industries in the town. Mill Street was once the only entry to the town from the south (the road from Abergavenny Hotel to the Swan was constructed in the nineteenth century). The mill, which stood on the south side of the street, was powered by waters of the mill race that ran under Tan House, and also by the Cibi brook which joins it just behind the house.

Inset: Mill Street showing Homes of Elegance towards the Swan Hotel.

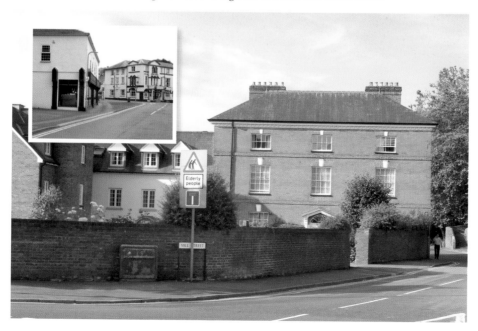

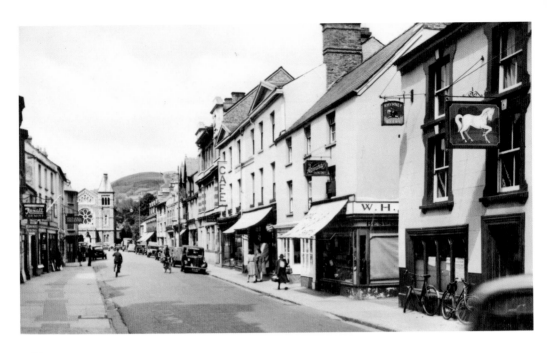

White Horse Inn

White Horse Inn with its distinctive sign in Frogmore Street gave its name to White Horse Lane. A few doors down was Scott's, the confectioner, which closed in 1979 when the owner retired. It had been trading in various parts of town for 145 years. As seen below, the pub has gone but the lane retains the name.

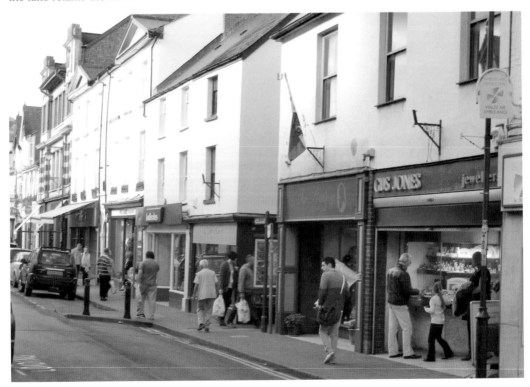

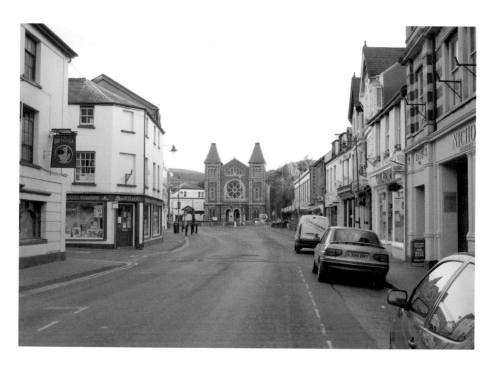

Frogmore Street

Frogmore Street with craft specialists Nantiago on the corner of the Richards store. Standing prominently at the end is the Abergavenny Baptist church, built in 1877. The original chapel building was across the street, but became too small for the size of the church congregation. More recently, Nantiago moved out to White Horse Lane and the Richards store moved in – only to announce the closure of their store in 2012.

The War Memorial

The war memorial, by Gilbert Ledward, in Frogmore Street stands as a tribute to the 3rd Battalion Monmouthshire Regiment who fell in the Great War. The memorial says, 'This plaque commemorates on the 8th May 1995 the 80th anniversary of 3rd Mons Memorial Day in the 1914–18 war. On that day in 1915 the battalion suffered heavy casualties in the second battle of Ypres.' The photograph was taken before the road alterations and the demolition on the houses on the right. Below is the war memorial in 2012, with the Whitefield Presbyterian church hidden by trees.

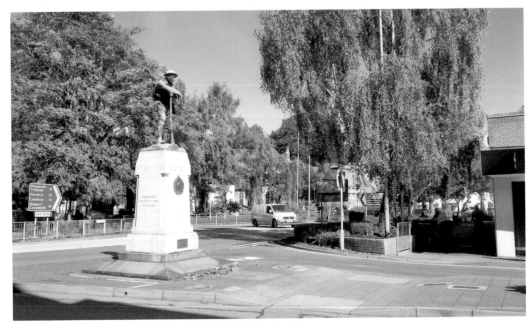

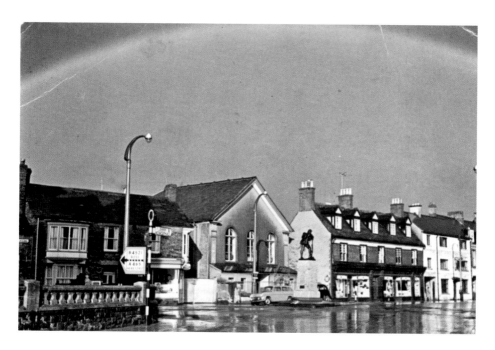

Frogmore Street

Frogmore Street in the 1950s before the Tesco supermarket was built. The Abergavenny Baptist church decided to sell off their original Frogmore Street chapel and memorial hall, pictured centre, and this helped to finance the adaptation and modernisation of the George Morgan's building. The old Baptist hall was used as the headquarters of the Home Guard during the Second World War. Below is another shot of the war memorial in 2012.

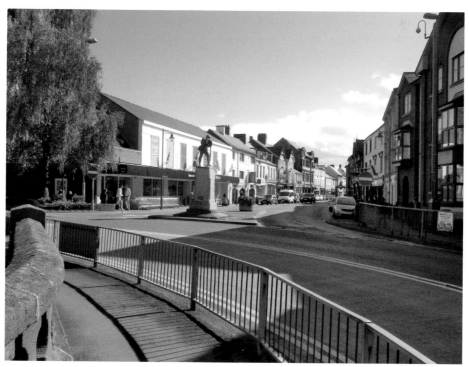

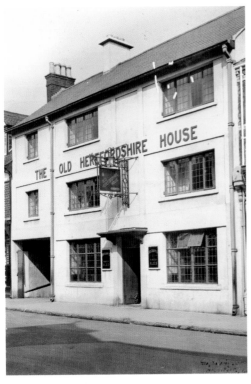

Herefordshire House
The old Herefordshire House following a refurbishment in the 1950s, and below, the pub with its new look – it has been renamed the Auberge.

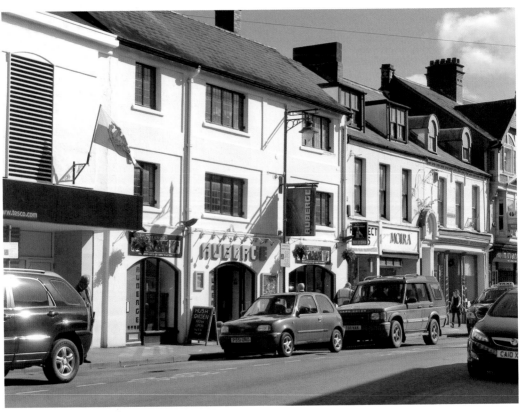

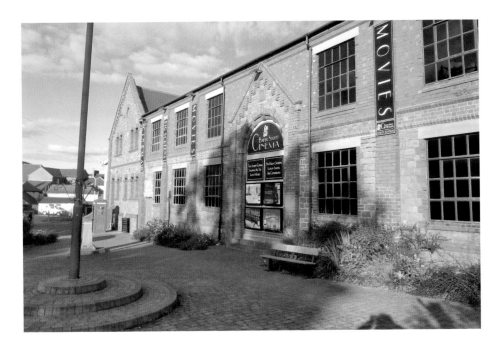

Drill Hall

The former Drill Hall is now the Baker Street Cinema. In November it was the venue for a royal film première when Prince Charles came to see the film *Resistance*; the novel was written by Abergavenny author Owen Sheers and he co-wrote the script for the film. Below is a memorial plaque on the side of the building.

Inset: Some of the soldiers who trained here during the Second World War left a permanent reminder and wrote their names on the outside bricks by the entrance.

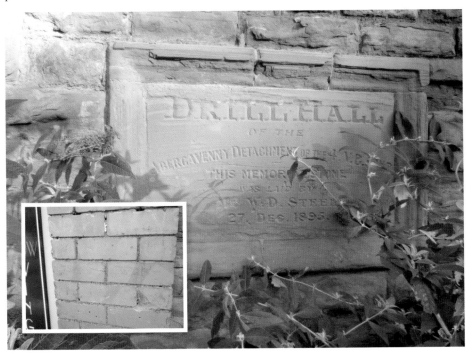

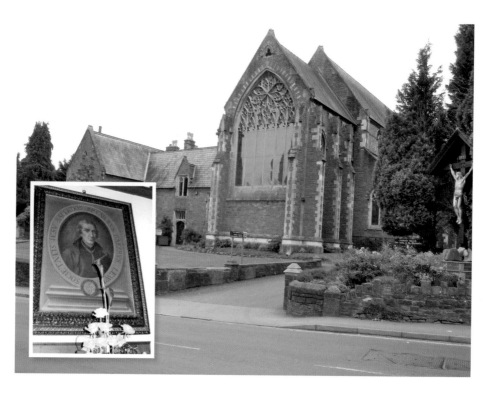

Church of Our Lady and St Michael

The foundation stone of the Roman Catholic Priory church of Our Lady and St Michael was laid on 19 May 1858. The church and presbytery were designed by Benjamin Bucknall, who had worked for the noted architect Pugin. The crucifix is a 1919 war memorial in memory of Captain Elidyr Herbert of Llanover, and the Abergavenny fallen, and the inset shows a memorial to St David Lewis. Below is the St Michael's Centre for community activities at the rear of the church.

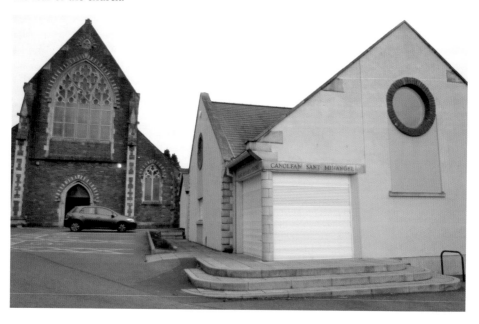

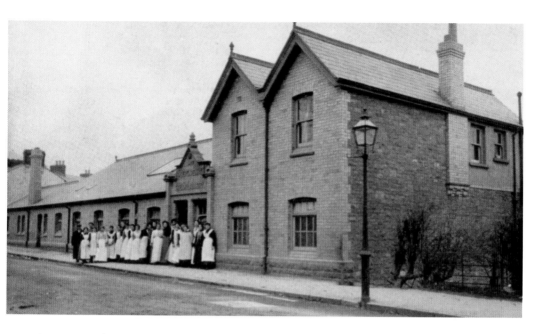

Steam Laundry

The girls employed at the Abergavenny Steam Laundry must certainly have earned their wages. The manageress, L. Devlin, assured prospective customers that all table linen was washed by hand, and no chemicals were used. The street behind the laundry is still called Laundry Place. Below, the premises are occupied by Little Treasures and TCM Carpets and Beds.

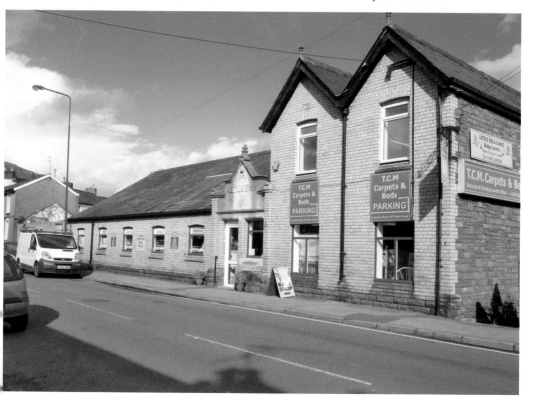

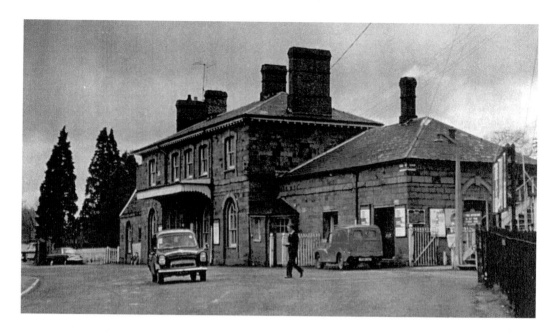

Monmouth Road Railway Station

Post was sent by rail and had to be collected daily on a regular basis when this picture was taken at the Monmouth Road railway station, Abergavenny. The station, one of three in Abergavenny, was built in 1854 for the Newport, Abergavenny & Hereford Railway, which later became part of the Great Western Railway, and is the only railway station left in the town. Below, GWR staff from the Monmouth Road station get ready for an outing by bus in this rare picture. The railway was an important employer in Abergavenny and many railway workers lived in the streets around Chapel Road, Stanhope Street and Union Road.

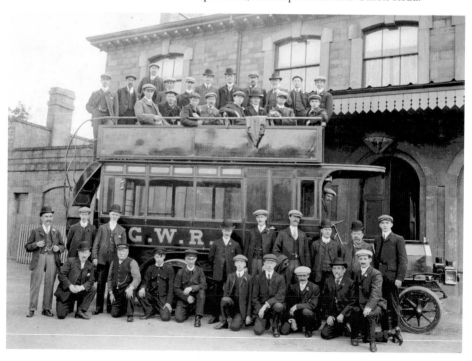

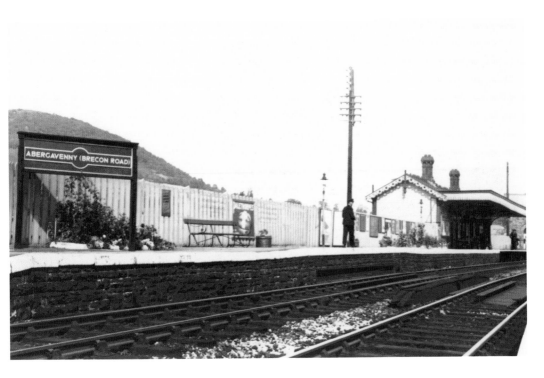

Brecon Road Station

Brecon Road was the third station to be built in Abergavenny. A doctors' surgery has replaced it on the site. Some of the trains at Abergavenny's huge engine sheds and workshops on what is now an industrial estate.

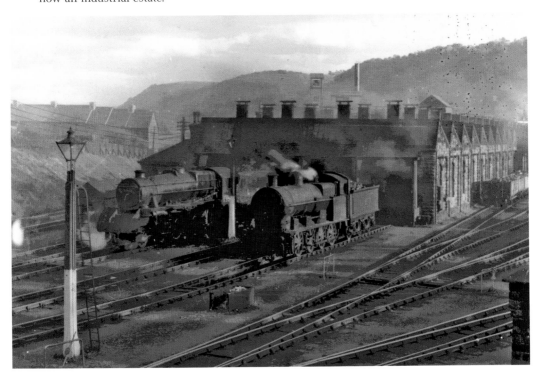

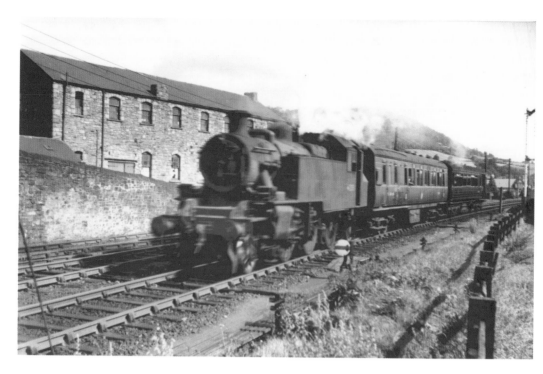

Engine Sheds and Workshops

The Link Road between Merthyr Road and Brecon Road has replaced the railway track – as you can see by the same stretch of wall that remains.

Inset: Plaque commemorating the LNWR in Abergavenny, on the Link Road near the site of the Brecon Road sheds.

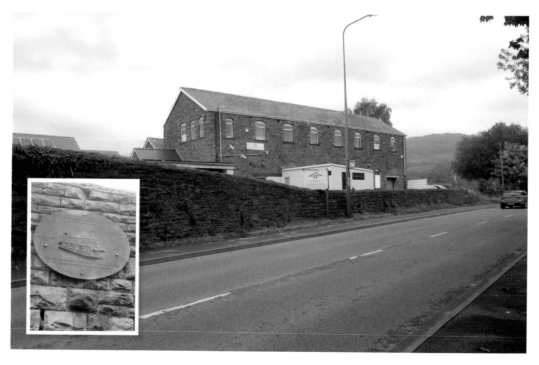

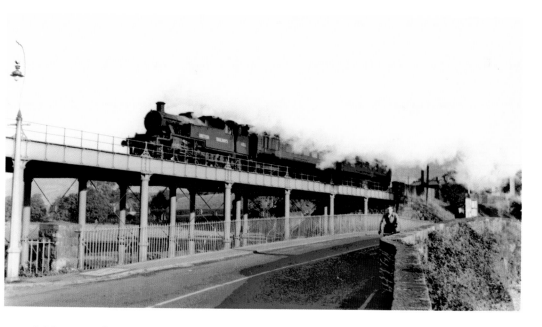

Bridge Over the River Usk

The railway bridge and road over the River Usk at Llanfoist with a steam train on its way to Brynmawr and Merthyr. The last train to Merthyr was in 1958. Below, a modern picture shows only the road bridge after the railway bridge was demolished. Little remains of the railway bridge apart from abutments.

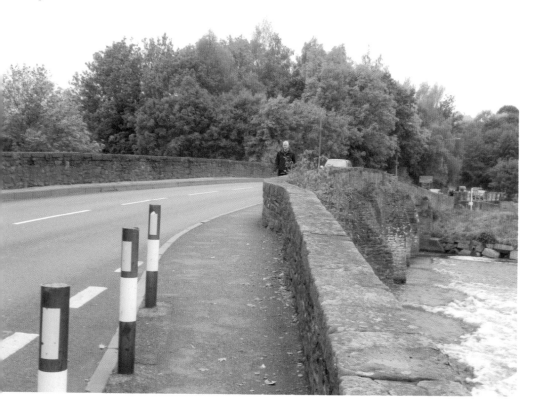

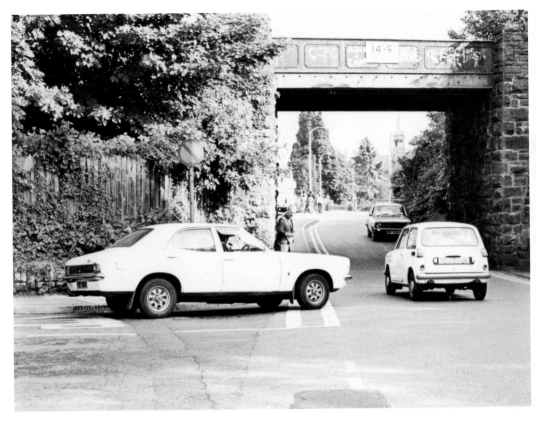

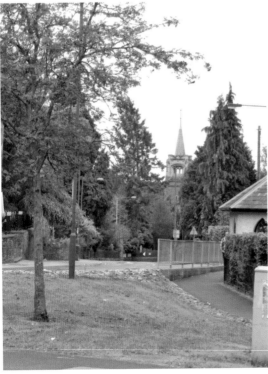

Pen-y-Pound I

The road turning into Pen-y-Pound looking toward the Whitefield Presbyterian church. Left is the same location after the railway bridge had been demolished and the junction of the Old Hereford Road and Pen-y-Pound has been realigned.

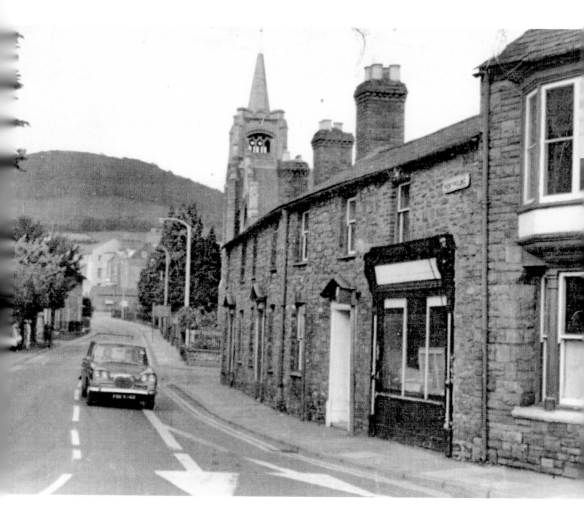

Pen-y-Pound II
The houses on Pen-y-Pound which have now been demolished.

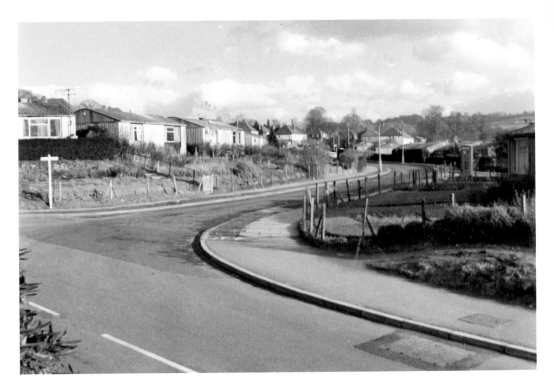

Prefabs

Estates of prefabricated buildings were built quickly and cheaply after the Second World War throughout Britain to ease the housing shortage. These prefabs were at Ysguborwen. Below, the flats and housing that were built to replace them.

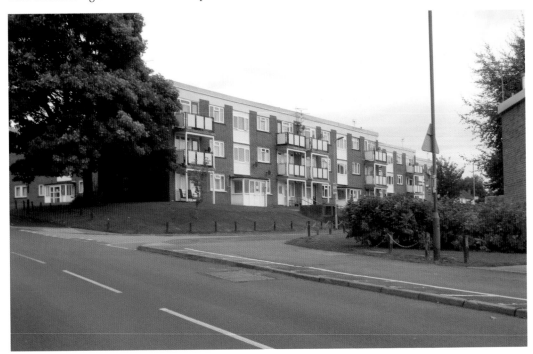

Acknowledgements

The majority of the archive photographs are from the collections at Abergavenny Museum, including the Bill Keen, Albert Lyons, Romley Marney and William Tribe collections, and are used with the museum's kind permission. The majority of the 2012 photographs and those from 2005 are from my own collection.

Thanks should go to the following for this book: Rachael Rogers and staff, particularly Sally and Janet; Councillor Samantha Dodd, the Mayor of Abergavenny, Abergavenny Town Council, and Peter Johns, Town Clerk; Lesley Flynn; Tony Flynn; Carolyn Stevens; Liz Davies, editor, Andy Sherwill, both of the *Abergavenny Chronicle*; Abergavenny Rotary Club; Chris Woodhouse; Stan Brown; Teresa Richards; Granville Hollister; Burrows Communications Ltd for permission to use the Eddie Madge photographs from the 1903 town guide; Jenny Barnes, and anyone who has helped.

Details about the archive photographs are from Abergavenny Museum supplemented by the Abergavenny Local History Society Street Survey.

And thanks must go to Gwyn Jones, president of Abergavenny Local History Society, and Frank Olding, former curator at Abergavenny Museum.

Proceeds from the book will go to Abergavenny Museum funds.

ALSO AVAILABLE FROM AMBERLEY PUBLISHING

'Breverton's breadth, generosity & sheer enthusiasm about Wales are compelling' *THE SUNDAY EXPRESS*

The WELSH

THE BIOGRAPHY

TERRY BREVERTON

The Welsh: The Biography
Terry Breverton

Available from all good bookshops or order direct from our website www.amberleybooks.com